IMAGES
of America

BALTIMORE'S
STREETCARS AND BUSES

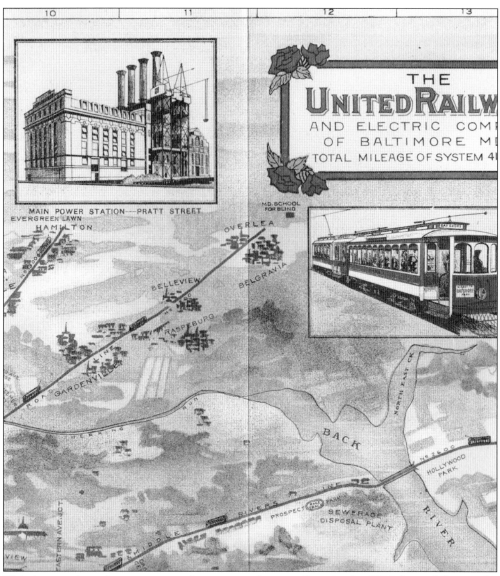

This is a portion of a system map that appeared as a pullout in the 1916 Annual Report for the United Railways and Electric Company. (Courtesy Maryland Rail Heritage Library of the Baltimore Streetcar Museum, Inc./Baltimore Chapter of the National Railway Historical Society [NRHS], Inc.)

ON THE COVER: This 1924 photograph taken at Charles and Baltimore Streets illustrates the variety of equipment being operated by the United Railways and Electric Company. At this single intersection are double-decked bus No. 104 headed north on Charles, a single-level bus driving south, and an articulated streetcar moving from East Baltimore Street across Charles to West Baltimore Street. (Courtesy Maryland Rail Heritage Library of the Baltimore Streetcar Museum, Inc./Baltimore Chapter NRHS, Inc.)

IMAGES
of America

BALTIMORE'S
STREETCARS AND BUSES

Gary Helton on behalf of the
Baltimore Streetcar Museum

ARCADIA
PUBLISHING

Published by Arcadia Publishing
Charleston SC, Chicago IL, Portsmouth NH, San Francisco CA

Printed in the United States of America

Library of Congress Catalog Card Number: 2007939752

For all general information contact Arcadia Publishing at:
Telephone 843-853-2070
Fax 843-853-0044
E-mail sales@arcadiapublishing.com
For customer service and orders:
Toll-Free 1-888-313-2665

Visit us on the Internet at www.arcadiapublishing.com

This book is dedicated to my grandson, Connor Riley Helton, whose great-great-grandfather Joseph Marshall (1902–1969) was once a Baltimore streetcar conductor. It is also dedicated to everyone who loves and works to preserve buses, streetcars, and all the other tangible things that connect us to our past.

CONTENTS

ACKNOWLEDGMENTS

My thanks to Jeff Korman and the staff of the Maryland Department of the Enoch Pratt Free Library in Baltimore for the assistance, contributions, and courtesies shown to me during the creation of this book. I also want to thank my son, Jason Helton, for rescuing me after a last-minute problem with my computer. Likewise, gratitude goes out to my ever-tolerant wife, Mary Ellen, who, with this being my fourth book, had "stuff" all over both the dining room and kitchen tables, and less than a week before our daughter Katie's wedding. Yes hon, I promise it is my last book.

And finally, I must thank all the volunteers at the Baltimore Streetcar Museum. I am particularly grateful to Jerry Kelly, Ken Spencer, Ray Cannon, Charles Plantholt, Bob Janssen, and Denis Falter, all of whom tolerated my many visits, questions, and special requests.

—Gary Helton
Bel Air, Maryland
October 14, 2007

INTRODUCTION

In the mid-19th century, Baltimore was the nation's second-largest city. Some 170,000 souls called it home and, needless to say, required some means by which to get around it. As early as 1844, stagecoach-like vehicles called omnibuses traversed the city's dirt roads and cobblestone streets, primarily transporting passengers between railroad stations and hotels—a 19th-century version of today's airport shuttle. However, it was obvious to city leaders that a more comprehensive service was needed.

On July 12, 1859, the Baltimore City Passenger Railway started free trial runs of the first chartered horse cars. Regular revenue service began on July 26. The initial fare was 3¢. About 20 people could be seated in those first horsecars, which operated over rails set 5 feet, 4.5 inches apart—the so-called "Baltimore Gauge" (this would become significant 80-plus years later during World War II).

For the next 30 years, additional independent horsecar lines competed against each other as well as omnibus operators throughout the city. They included: Citizen's Railway; Baltimore, Catonsville, and Ellicott's Mills Passenger Railway; People's Passenger Railway; Baltimore and Yorktowne Turnpike Railway; Central Railway; Baltimore and Hall's Springs Railway; Union Passenger Railway; and several others.

In addition to horsecars, Baltimore was the venue for the nation's first electrically powered streetcars courtesy of an enterprising man named Prof. Leo Daft. His power unit, which resembled a large windowed box, drew current from a third rail laid in the street between the travel rails and, on August 10, 1885, replaced mules on the windy, hilly Hampden line of the Baltimore Union Passenger Railway. Although the Daft system operated there just four years, it set into motion the eventual conversion of Baltimore's streetcars from horsepower to electricity. During the 1890s, the Baltimore Traction Company established yet another mode of public mass transit, a long forgotten San Francisco–like cable car network. The die was cast, and as the century came to a close, electric streetcars using overhead lines (much safer than a third rail) were accepted as the most viable option not just in Baltimore, but in cities across America.

With everyone now on the same page technically, it was also time for a single, cohesive, central operation of the city's public transit network. In 1899, the surviving independents merged to form the United Railways and Electric Company, whose first obstacle was to coordinate service citywide using, in many cases, old, worn-out, and incompatible equipment. With the exception of the World War II years, it would be an uphill and ultimately insurmountable task with bankruptcy, a name change, and a corporate and eventually state takeover along the way. But for the next 70 years, it was a fascinating, frustrating, colorful, and often controversial ride.

Historically, rail fans and bus aficionados have rarely been found in the same room together. The purpose of this book is not to analyze the fascinating, frustrating, and controversial history of public mass transit in Baltimore. It is merely to find a little common ground by revisiting the colorful, literally speaking. For many, Baltimore's streetcars and buses did more than just get us from Point A to Point B. Some of us bonded with longtime drivers, motormen, and conductors.

Many more still have a place in their heart for one or more of the myriad vehicles that made up the fleet. Seeing them today reminds us of happy, perhaps simpler times; of old jobs and coworkers; refuge from the city's oppressive heat and humidity on a summer night; outings to Bay Shore Park; movies at the Grand; ball games at Memorial Stadium; or the only means to visit grandma. They took Baltimoreans to and from school, to visit a sick friend at Church Home, to fish from the pier at Back River, to bowl ducks at the Spillway on Monument Street, to Christmas shop at Howard and Lexington Streets, or to catch a live radio broadcast at WFBR on North Avenue. This publication covers vehicles used until the private operation of the Baltimore Transit Company ended in 1970.

Unless otherwise noted, photographs featured in this book are courtesy of the Maryland Rail Heritage Library of the Baltimore Streetcar Museum, Inc./Baltimore Chapter of the National Railway Historical Society (NRHS), Inc.

One

THE BEGINNING
OMNIBUSES AND INDEPENDENTS
1859–1899

While the omnibus had been around for 15 years, public mass transit officially arrived in Baltimore on March 28, 1859. The legislation had been passed and signed off on by the mayor, Thomas Swann. City leaders had authorized construction of a street railway. A significant provision required carriers to forfeit 20 percent of their gross revenues back to the city to support its public parks.

The Baltimore City Passenger Railway was first. Others followed suit, including the Baltimore Traction Company, City and Suburban Railway, Central Railway, Baltimore Consolidated Railways, the North Avenue Railway Company of Baltimore City, Lake Roland Elevated Railway, and more. In short order, the system looked like a patchwork quilt. Equipment was just as varied as the companies that operated it, with cars painted in Allentown red, Baltimore green, chrome-yellow-orange, raw umber, cream and olive, and Tuscan red. Equally diverse, pulling power was provided by horses, mules, overhead wires, underground cable, a third rail, and steam. The only thing consistent was the so-called Baltimore Gauge, which required rails to be 5 feet, 4.5 inches apart—"the same as that of ordinary street carriages," as City Ordinance No. 44 read. This way, horse-drawn wagons could ride on the smoother rails as opposed to rutted dirt roads and cobblestones.

Toward the end of the 19th century, competition and technology became the driving forces in the transit system. Smaller lines were absorbed by larger ones. Cable cars disappeared almost as quickly as they had arrived. Steam-powered units operating in Druid Hill Park had worn out and were replaced by horsecars. In 1885, Prof. Leo Daft of New Jersey successfully introduced his third-rail system in Hampden, giving Baltimore the distinction of having the nation's first electric railway. Within three years, another entrepreneur, Frank Sprague, revolutionized the industry with electric streetcars powered by overhead lines. In 1889, a year after the first Sprague system began operations in Richmond, Daft's third-rail units were replaced by horses and mules. Ten years later, the lines that remained came together as a single unit, the United Railways and Electric Company.

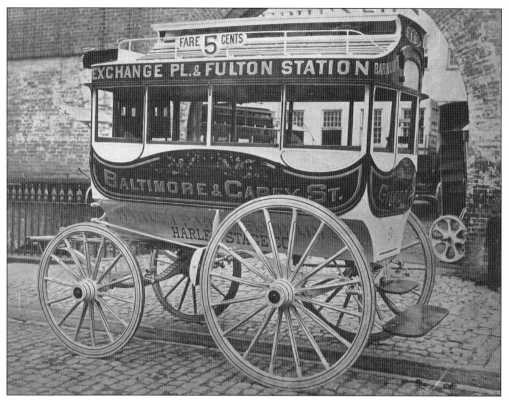

The earliest public mass transit vehicle was the horse-drawn omnibus, an urban version of the stagecoach. This one, photographed in the 1880s or 1890s, was set up in front of the John Stephenson plant on East Twenty-seventh Street in New York, where it was built.

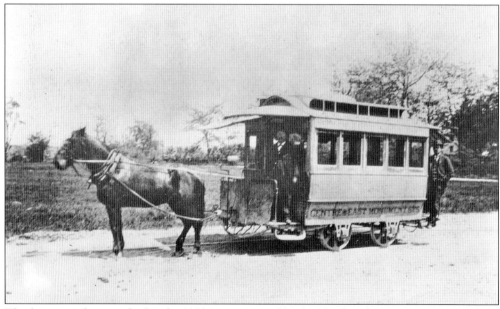

This horsecar, photographed in the 1880s, was operated by the North Baltimore Passenger Railway. Its route terminated at Centre and East Monument Streets not far from Johns Hopkins Hospital.

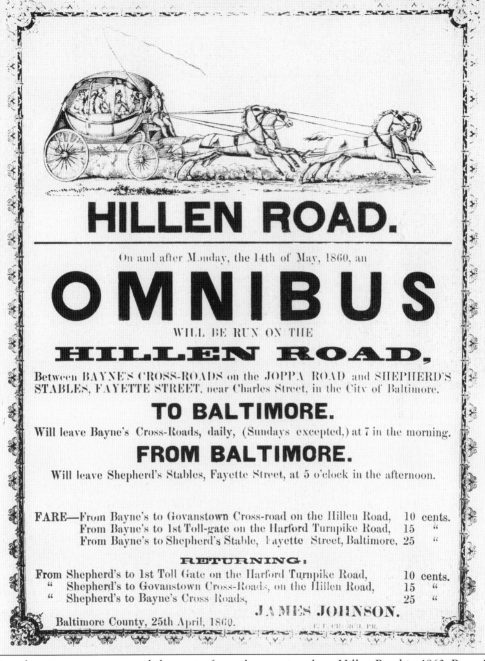

An advertisement announced the start of omnibus service along Hillen Road in 1860. Bayne's Cross-Roads is now referred to as Baynesville. The 25¢ fare between there and Shepherd's Stables—a distance of about 10 miles—was significant by 1860 standards.

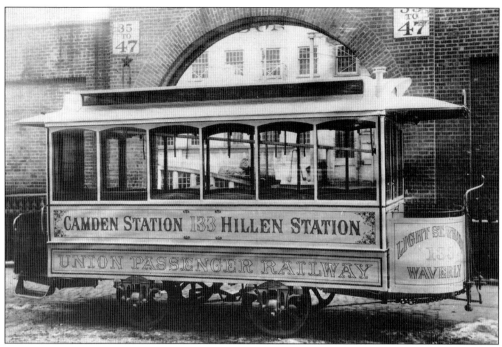

This 1890s shot shows a Union Passenger Railway horsecar in front of the John Stephenson plant in New York. Stephenson began building cars in 1832.

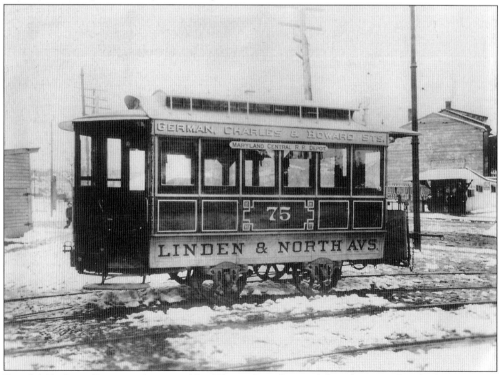

People's Railway Company horsecar No. 75 was the subject of this photograph, which was taken in 1892.

The operator of Baltimore City Passenger Railway (BCPR) cable car No. 29 used the large wheel at the far right to grab and release the ever-moving cable recessed in the street between the rails. An attached open car trails behind in this *c.* 1895 shot taken either on Smallwood or West Baltimore Street.

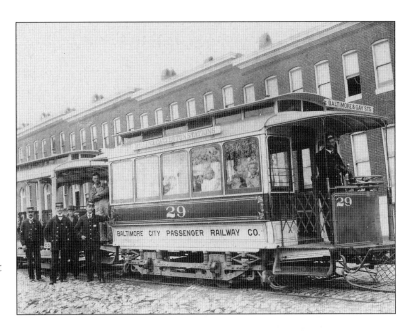

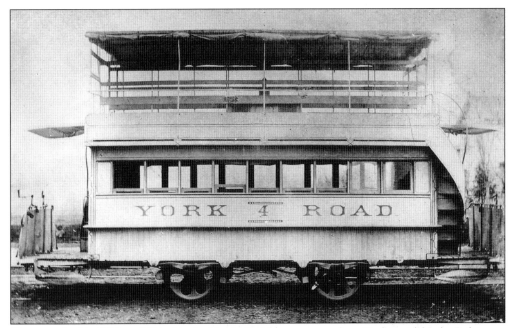

Photographed in 1883 or 1884, this double-decked horsecar ran along York Road for the Baltimore and Yorktown Turnpike Railway (B&YTR), which began operations in 1863. Prior to 1870, African Americans were not allowed to ride inside Baltimore's street railway cars. At least one of the B&YTR double-deckers was used as a "Jim Crow" car, isolating African Americans on the open top deck. A lawsuit filed against the Baltimore City Passenger Railway in 1871 ended segregation on the local rails.

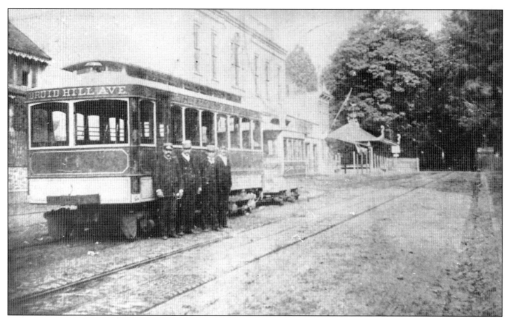

This is a Baltimore Traction Company cable car and trailer at Druid Hill Park in the early 1890s. The line operated from 1891 to 1896.

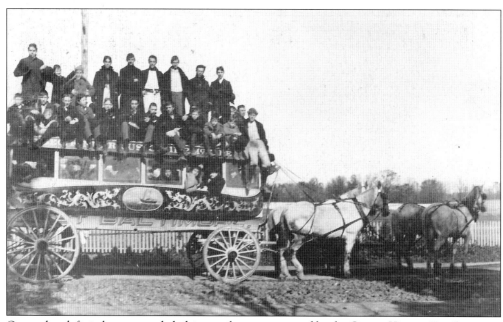

Ornate but definitely overcrowded, this omnibus was operated by the George Kinnier Bus Company of McElderry Street. Photographed in the 1880s, it is en route to a football game carrying the Madison Athletic Club's football team and some of their fans.

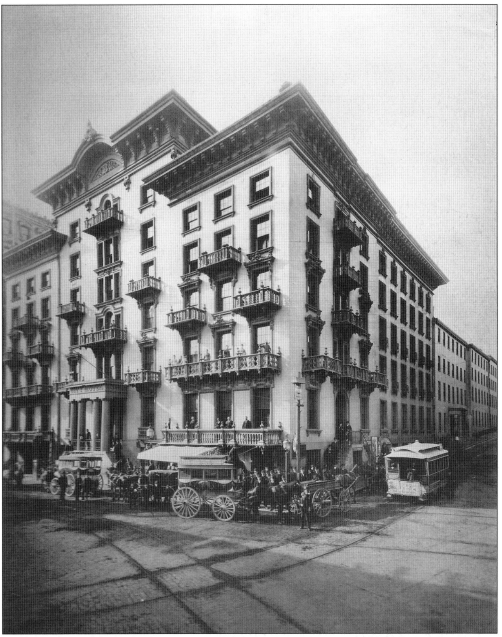

Horsecars and omnibuses were clustered around Barnum's City Hotel on Calvert Street when this photograph was made sometime between 1875 and 1880. The Citizen's Railway horsecar is headed west on Fayette Street. Built in 1827, the hotel was razed in 1889. (Courtesy Maryland Department, Enoch Pratt Free Library.)

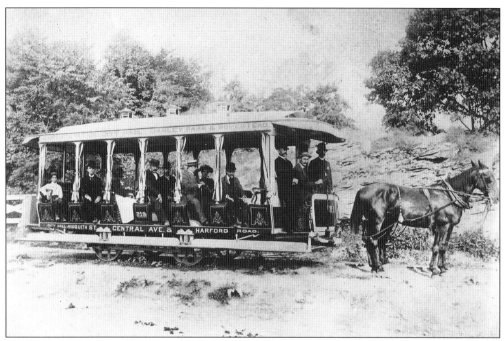

This 1880s shot of an open horsecar was taken at Aisquith Street and Central Avenue. Its route terminated at Hall's Spring near the present-day intersection of Harford Road and Walther Boulevard.

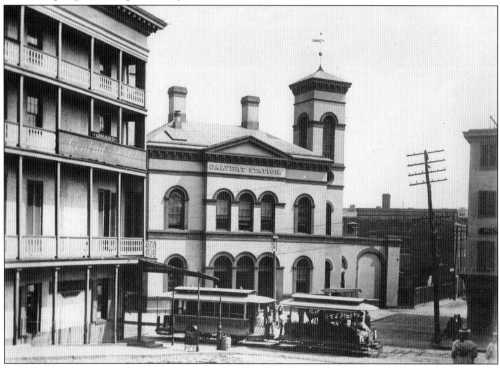

Cable cars are captured on the Blue Line passing the Calvert Station in this 1893 or 1894 photograph. The Northern Central Railroad served Calvert Station, which was situated at Calvert and Franklin Streets.

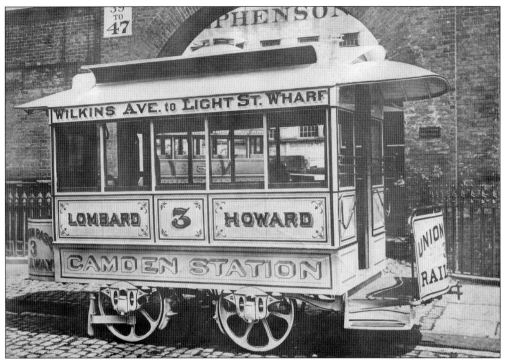

Union Passenger Railway horsecar No. 3 poses for this 1890s photograph in front of the John Stephenson plant. As electric cars replaced horsecars, the Stephenson company fell on hard times and was dissolved in 1898, five years after the death of its founder.

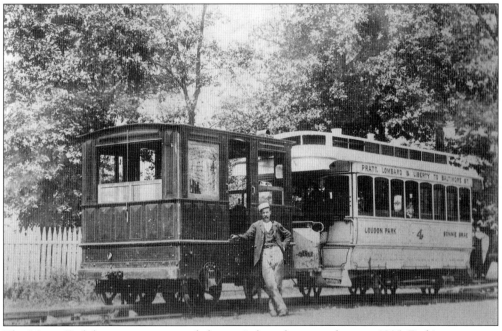

The Morse Daft locomotive powered the city's first electric railway in 1885. Daft's power unit consumed 220 volts of electricity that was fed from a third rail between the travel rails. (Courtesy Maryland Department, Enoch Pratt Free Library.)

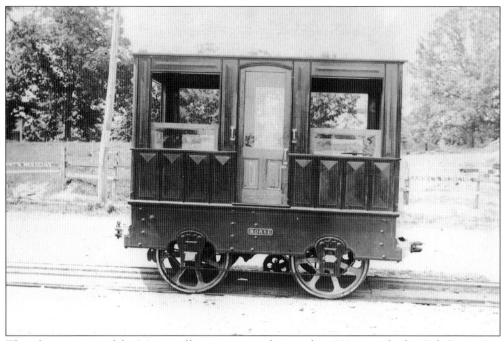

This close-up view of the Morse pulling unit was taken in the 1880s outside the Oak Street Car Barn near the present-day intersection of Howard and Twenty-fifth Streets.

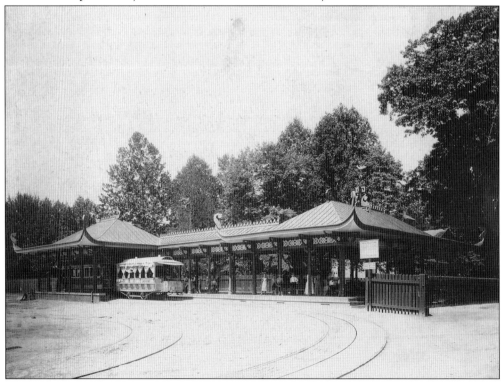

This deluxe grip-handled cable car—complete with window curtains—was photographed at the Druid Hill Park pavilion in the 1890s. Open trailer No. 68 is attached.

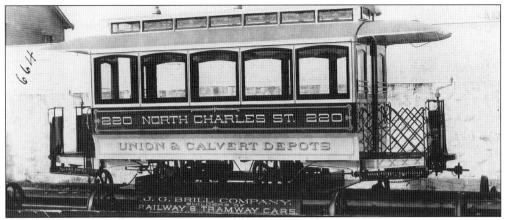

Closed trailer car No. 220 operated over the Blue Line along Calvert Street. Built by the J. G. Brill Company of Philadelphia, it was delivered to the Baltimore City Passenger Railway in December 1892.

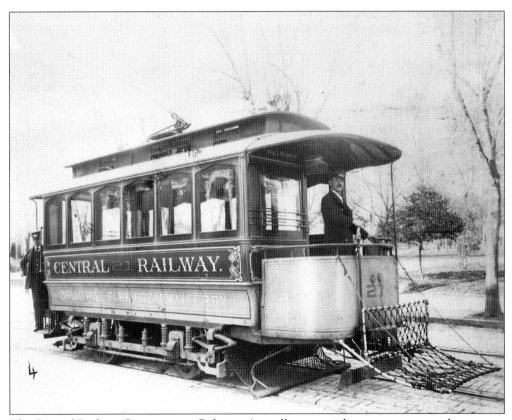

The Central Railway Company was Baltimore's smallest transit line, operating just three routes between 1892 and 1897. Car No. 21 was a 16-foot closed car built by Brill in 1893. (Courtesy Maryland Department, Enoch Pratt Free Library.)

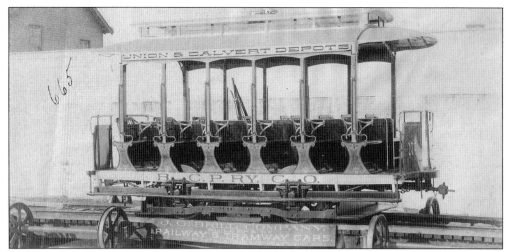

Photographed in 1892, this was one of 62 grip-handled cable cars built by Brill. Other cable cars used a wheel to grab and release the pulling cable recessed into the street.

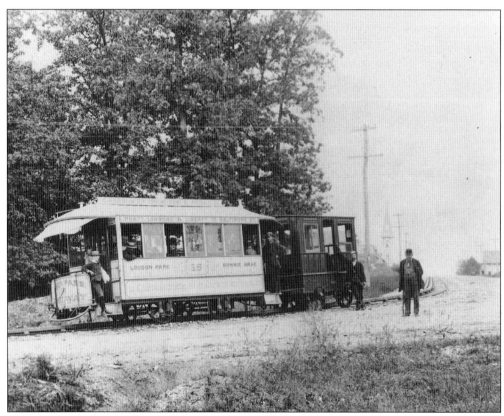

This shot was taken in the 1880s in the vicinity of Thirty-third and Chestnut Streets. A Daft pulling unit and a Union Passenger Railway car are shown on the Hampden line.

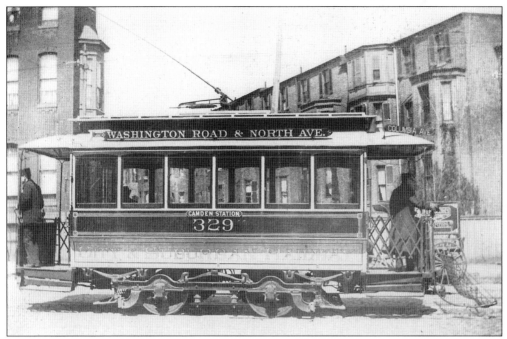

City and Suburban Railway No. 329 is seen in this photograph taken around 1900 while operating eastbound on North Avenue at John Street. Built by the Laclede Car Company in 1894, it was scrapped just 11 years later in 1905.

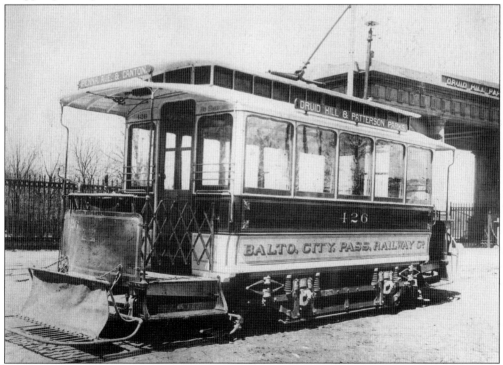

Baltimore City Passenger Railway No. 426 is the subject of this c. 1900 photograph taken at the Madison Avenue entrance of Druid Hill Park.

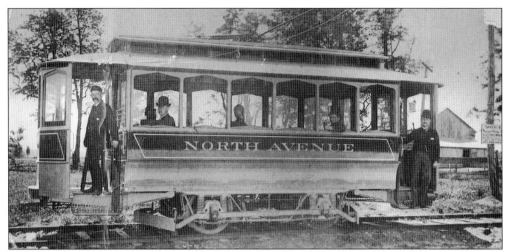

The North Avenue Railway Company of Baltimore City began service in 1890. Built by Brill, car No. 1, shown here, was the first conventional electric car in Baltimore. Finished in cherry and mahogany, and featuring a carpeted floor, it was destroyed in 1898 when fire engulfed the Irvington car house.

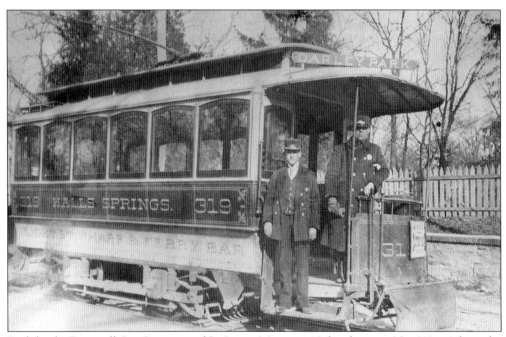

Built by the Brownell Car Company of St. Louis, Missouri, 18-foot-long car No. 319 ran from the basin area (today's Inner Harbor) to Hall's Springs off Harford Road. An unidentified motorman and conductor pose for this photograph in 1893.

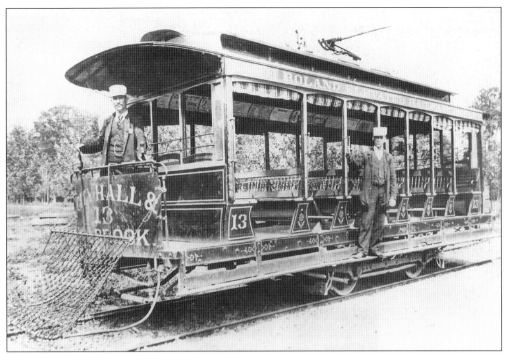

Open car No. 13 of the Lake Roland Elevated Railway Company was large—31 feet from end to end—and featured eight benches measuring 6 feet, 9 inches across. It was built by the Lewis and Fowler Manufacturing Company of Brooklyn, New York, in 1893 and was later used by the Baltimore City and Suburban Railway along its John Street route until 1906.

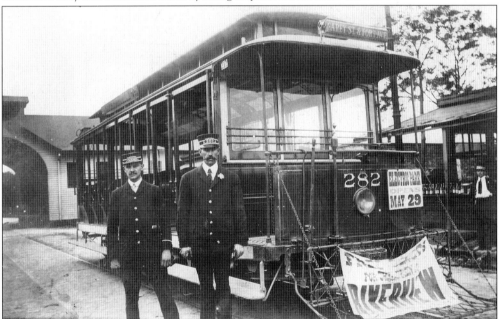

Baltimore Traction Company No. 282 was an eight-bench open car built by Brownell in 1895. Note the temporary signs promoting Electric and Riverview Parks. This shot was taken at Druid Hill Park in May 1898.

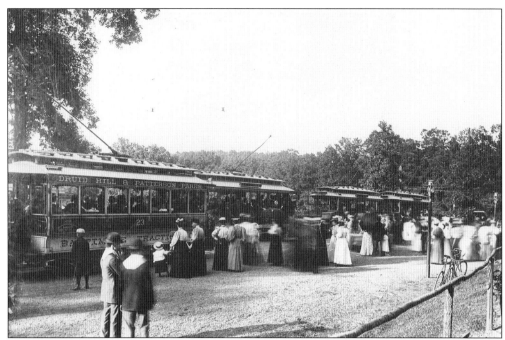

Gwynn Oak Park was the setting for this photograph taken on a summer day in 1897 or 1898. Closed car No. 23 (left) remained in service until 1918. The other cars in this photograph are eight-bench open cars.

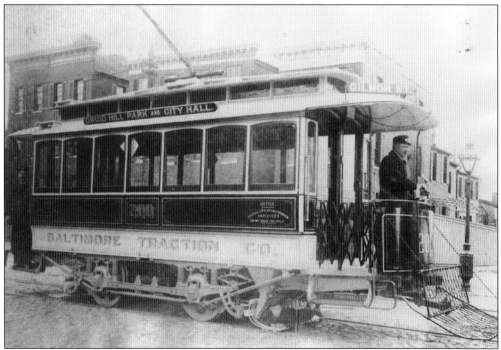

Closed car No. 200 is seen in late 1894 or early 1895 operating over Baltimore Traction's Gilmor Street line. It sported a Tuscan red paint job. During its lifetime, the car was renumbered three times and operated until 1918.

A Faraday pulling unit is the subject of this photograph from the mid-1880s. Like the Morse unit, it drew electricity from a third rail in the street—a potentially dangerous setup for passing horses and pedestrians.

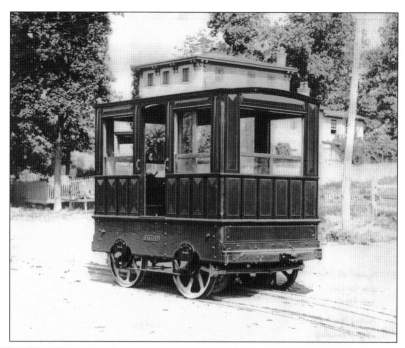

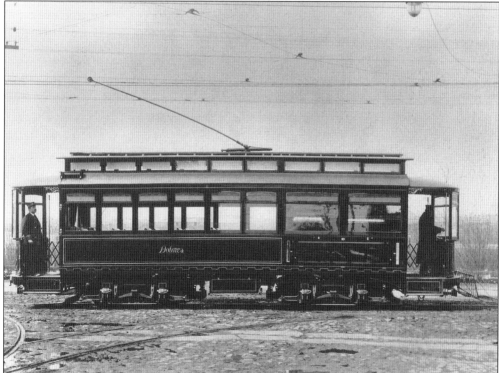

Dolores was the name given to this special car (No. 3096), which was used for funerals. Mourners were charged between $20 and $25 for its use depending upon the location of the cemetery. The United Railways and Electric Company kept Dolores busy until 1927—it seems people were dying to ride in her.

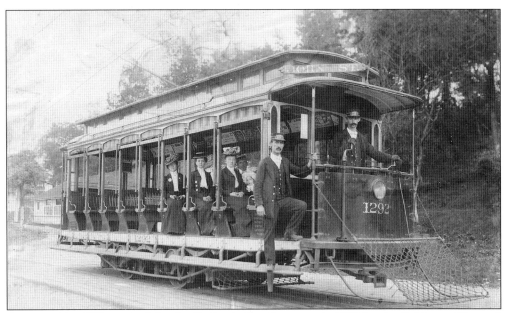

Open car No. 1292 was built by the St. Louis Car Company in 1897 for the Baltimore City and Suburban Railway. Originally numbered 158, it operated between Westport and John Street until it was scrapped in 1918.

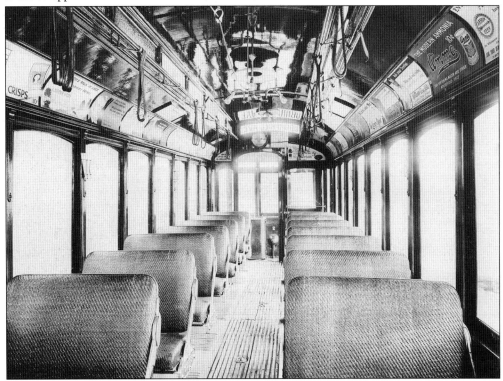

This c. 1900 view shows the interior of convertible car No. 8, a 23-footer made by Brill in 1898 for the Baltimore Consolidated Railway Company. The rattan seat backs were reversible to allow for two-way operation. It was used until 1924.

North Avenue Railway No. 7, manufactured at John Stephenson's plant in 1891, ran along North Avenue until 1897 when it was rebuilt as U.S. Railway Post Office car No. 400. It operated for another 33 years after the conversion from passengers to mail carrier.

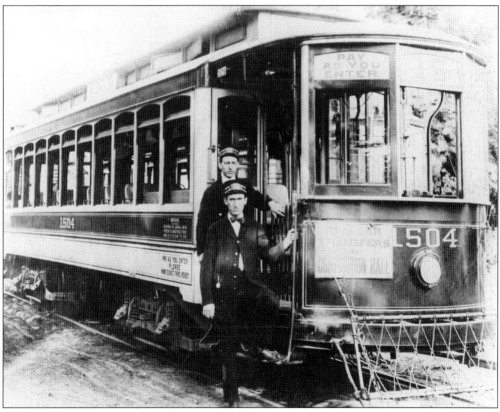

Baltimore City Passenger Railway No. 1504, an 18-foot closed car, started life in 1893 as No. 304. It originally ran on the Hall's Spring line. As semi-convertibles began arriving in 1905, the 18-footers were taken out of service, and all but a handful were sold. This car went to the Hummelstown and Campbellstown Street Railway, a line that was financed by Milton Hershey and built largely to transport workers to and from his chocolate plant in Hershey, Pennsylvania.

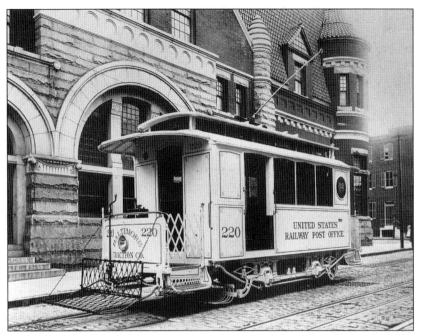

This image, believed to be from the 1890s, shows Railway Post Office (RPO) No. 220 on Druid Hill Avenue.

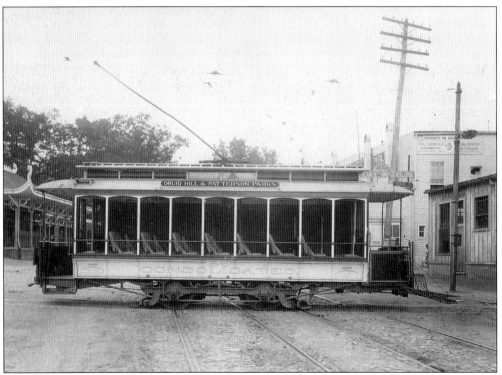

Baltimore Consolidated Railway open car No. 26 was photographed at Druid Hill Park around 1898. Consolidated was formed on June 7, 1897, following the merger of the Baltimore Traction Company with the Baltimore City and Suburban Railway. Originally built for cable service in 1891, No. 26 was modified for electric operation in 1896. (Courtesy Maryland Department, Enoch Pratt Free Library.)

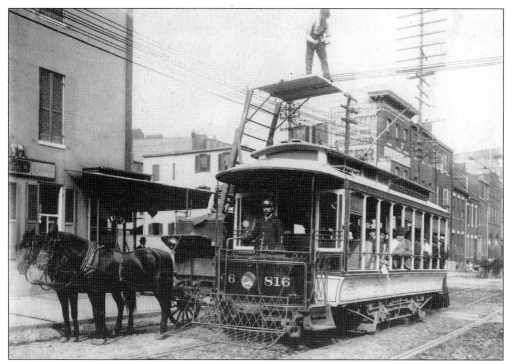

Consolidated No. 816 is seen here in 1898 at Baltimore and Eutaw Streets. A 23-foot Brill convertible, it was used until 1926. Alongside it, work is underway on the overhead trolley lines.

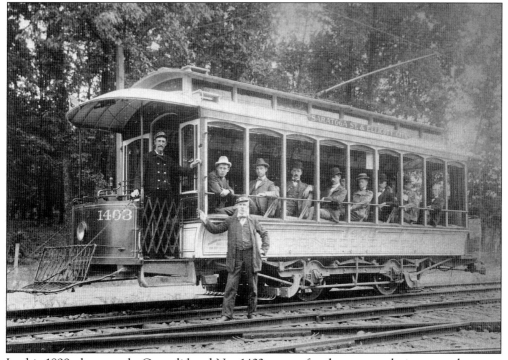

In this 1899 photograph, Consolidated No. 1403 pauses for the camera during a run between Baltimore and Ellicott City.

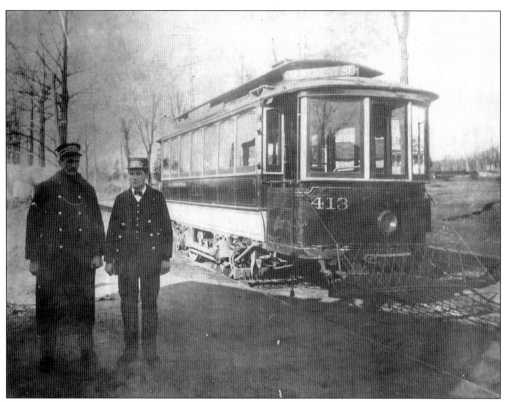

Driving down Monument Street today, one would never imagine it was once the pastoral setting captured in this 1899 photograph with No. 413 and its crew.

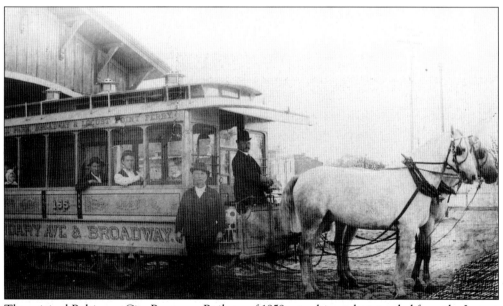

The original Baltimore City Passenger Railway of 1859 was ultimately extended from the Locust Point Ferry at the foot of Broadway to Boundary Road, now North Avenue. This undated image is believed to be from the 1870s.

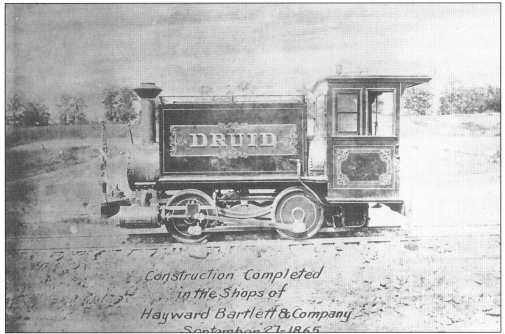

Incorporated in 1862, the City Park Railway Company both operated and contracted the operation of steam-powered rail service between North and Madison Avenues and Druid Hill Park. The Druid, show here shortly after its construction in 1865, was one of three steam locomotives used.

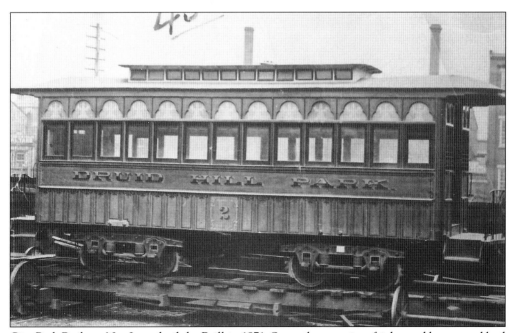

City Park Railway No. 2 was built by Brill in 1871. Steam locomotives frightened horses and had a difficult time with the hilly terrain of Druid Hill Park.

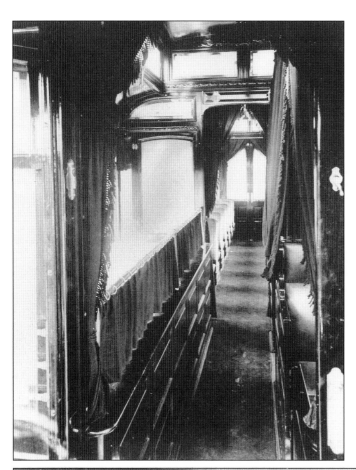

This undated interior view of the funeral car Dolores reveals the bier for the casket at the left, seating for the immediate family at the right, and seats for additional mourners in the rear.

A plaque affixed to the Oak Street car house commemorated the first electric railway operation in America, Daft's third-rail system.

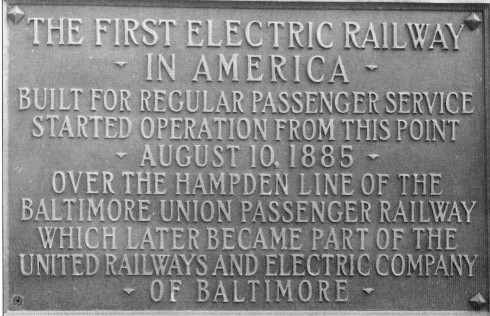

THE FIRST ELECTRIC RAILWAY
- IN AMERICA -
BUILT FOR REGULAR PASSENGER SERVICE
STARTED OPERATION FROM THIS POINT
- AUGUST 10, 1885 -
OVER THE HAMPDEN LINE OF THE
BALTIMORE UNION PASSENGER RAILWAY
WHICH LATER BECAME PART OF THE
UNITED RAILWAYS AND ELECTRIC COMPANY
- OF BALTIMORE -

Two

THE UNITED RAILWAYS AND ELECTRIC COMPANY

The United Railways and Electric Company was faced with an awesome task right from the start. It basically had to covert a 40-year-old hodgepodge of neighborhood transportation lines into a modern, cohesive system to serve a metropolitan area that had grown to more than half a million residents. In order to do so, they first had to find a way to work with hundreds of vehicles of various ages, sizes, colors, and conditions from more than a dozen manufacturers. The process of inventorying and renumbering cars must have been a daunting one in and of itself. Nearly 150 of United's 1,200-car fleet were rebuilt horse and cable cars. Many others were simply too small to handle the increasing demand. The brain trust at United had to act fast.

One of the first things United accomplished was the establishment of a centralized repair and remodeling facility at Carroll Park in southwest Baltimore. Then, under the direction of John Mifflin Hood, a wounded veteran of the Confederate army and former head of the Western Maryland Railroad, United began ordering new, larger cars, first from the Brownell Car Company of St. Louis, then from the J. G. Brill Company in Philadelphia. Setbacks included the Great Baltimore Fire of 1904, which destroyed United's central offices and damaged the Pratt Street powerhouse. There was also a series of devastating car house fires. Then Hood died in 1906 at age 63. Otherwise, the first two decades of United's existence were characterized by steady growth, modernization, and expansion.

The first motorized buses hit the streets of Baltimore in 1915 when, in response to hundreds of independent jitney drivers, United formed a subsidiary prophetically called the Baltimore Transit Company. During World War I, they began hiring women to serve as streetcar conductors. Older cars were sold off whenever possible, but the Baltimore Gauge caused sales to be limited. Some cars went for the rock-bottom price of just $100. Many more were scrapped, while others simply went into storage, a move that would prove visionary after December 7, 1941.

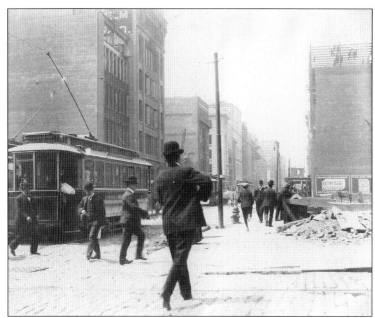

The Great Baltimore Fire of 1904 destroyed more than 1,500 buildings over a 70-block area. Many streets were clogged with bricks and debris for months. In this *c.* 1906 photograph, several pedestrians and streetcars are seen making their way as best as possible, while signs of rebuilding were evident at the intersection of Charles and Baltimore Streets.

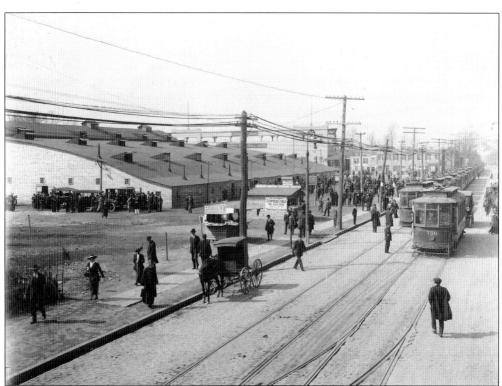

A large number of streetcars were required to transport the throngs who came to see and hear evangelist Billy Sunday preach in 1915. Prior to becoming an evangelist, Sunday was a fleet-footed outfielder for the Chicago White Stockings, the Pittsburgh Alleghenys, and the Philadelphia Phillies. As fate would have it, Sunday's crusade this day was at the old Oriole Park at Twenty-ninth Street and Greenmount Avenue.

This is the intersection of Belair Road and Overlea Avenue in 1925, looking east on Overlea. The No. 15 streetcar has entered the Overlea loop to the right, while a McMahon Transportation Company bus waits in the background, bound for Bel Air. This McMahon bus is an old United Railways and Electric Company vehicle once used on Charles Street.

The scene is West Baltimore Street at Liberty Street on May 28, 1919, and the shops and street are adorned for Memorial Day, then called Decoration Day. Brill convertible No. 243 is front and center—its windows removed for summer service—on the No. 2 line, which ran between Carey Street and Fort McHenry.

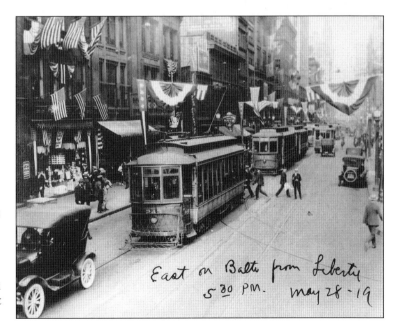

East on Balto from Liberty 5 30 pm. may 28 - 19

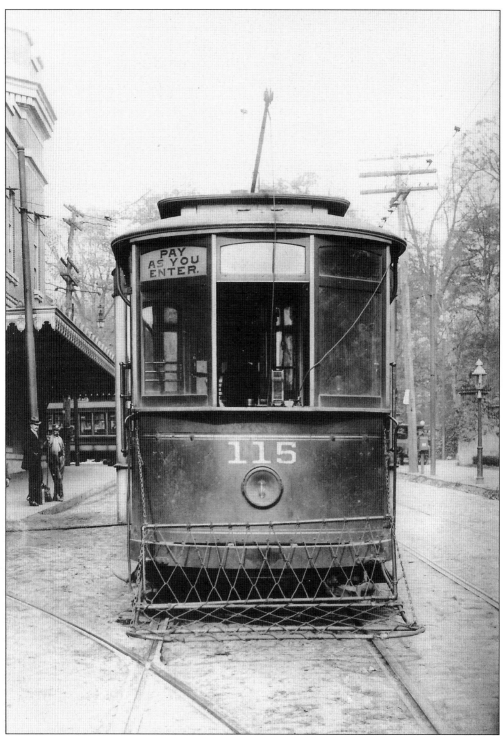

Car No. 115, shown in this 1910 photograph at Park Terminal, was a PAYE car. PAYE was an acronym for "Pay As You Enter." Prior to this method of fare collection, conductors would walk about the cars to collect fares from riders.

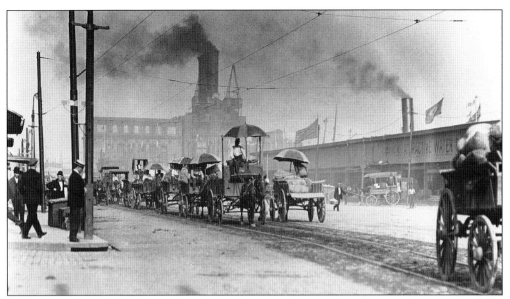

Streetcars were touted as clean-running vehicles, but the plants that supplied electricity for them certainly were not, as this shot from the early 1900s will attest. Seen from Light and Pratt Streets, the United Railways' coal-burning power plant belches thick black smoke behind a column of horse-drawn wagons heading west on Pratt. Today the building is a tourist attraction housing the popular ESPNZone as well as a Barnes and Noble bookstore.

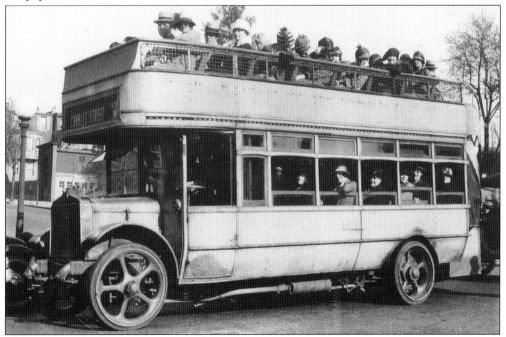

Hard rubber tires must have made for a rough ride up Charles Street on bus No. 107 in the 1920s. United began providing bus service (calling this subsidiary the Baltimore Transit Company) in 1915 in response to a proliferation of unregulated jitney drivers who siphoned away streetcar passengers using crudely modified motor vehicles. Jitney passengers sat on benches placed inside or clung to the outside of the vehicle while standing on homemade running boards.

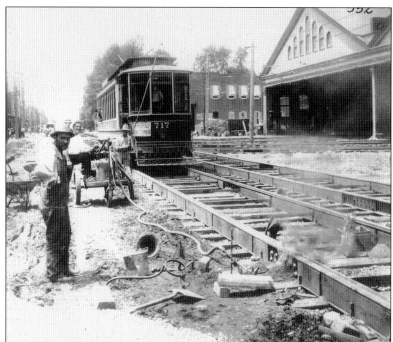

Track work along Frederick Avenue stops car No. 717 momentarily on a hot day in June 1914. A semi-convertible, No. 717 was one of 160 cars built for United by the J. G. Brill Company in 1905 at a cost of $4,958.48 each.

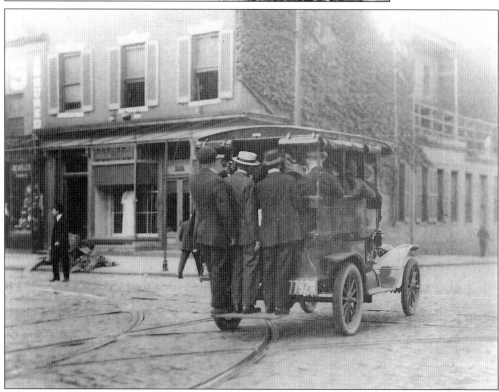

Nearly a dozen people crowd onto a jitney bus in this 1915 photograph. It seems safe to assume that jitney operators were not required to contribute any portion of their income to the upkeep of city parks.

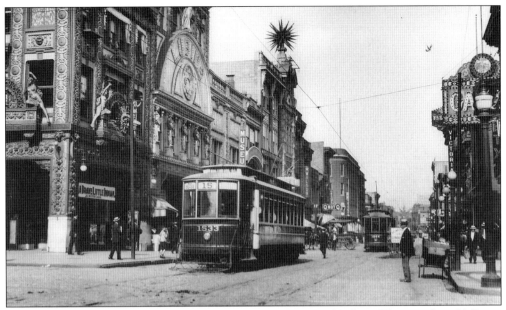

At Baltimore and Commerce Streets, Brill semi No. 1533 passed Lubin's Theatre where "A Brave Little Indian," a 1912 western short, was playing. This area eventually became known as "The Block," Baltimore's infamous adult entertainment district.

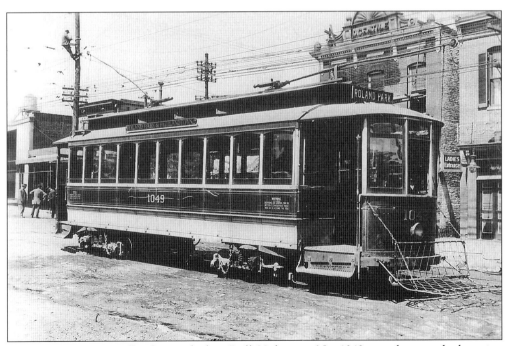

Eastern Avenue was still a dirt road when Brill 28-foot car No. 1049 was photographed passing through Highlandtown en route to Dundalk. Built in 1902, No. 1049 ran until 1931.

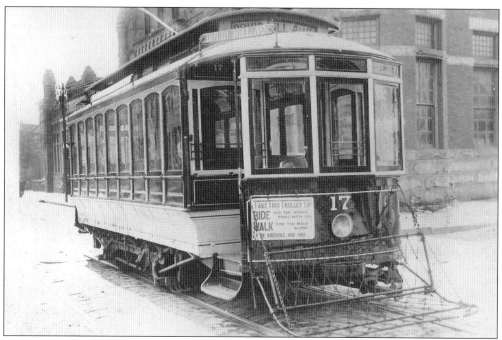

Built in 1898 for the Baltimore Consolidated Railway, No. 17 ran on the Druid Hill Avenue line until 1920. This undated photograph was taken on Druid Hill south of Fulton Avenue.

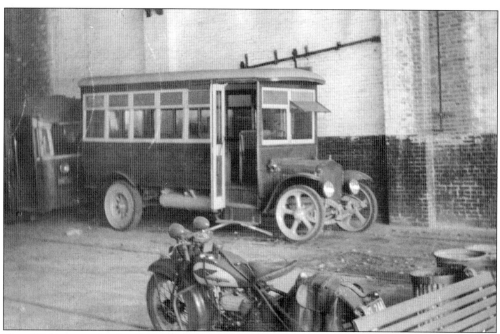

This 1915 bus now on display at the Smithsonian Institution in Washington, D. C., and a vintage motorcycle are the subjects of a photographer's lens in this picture taken inside the old Baltimore Traction Company garage at 1711 North Charles Street. Built in the 1890s, this versatile building has served as a cable car and streetcar barn, a powerhouse, a bus garage, a library for the blind, a newsreel theater, and the Famous Ballroom, a jazz venue. Today it is the Charles Theatre.

Baltimore City Passenger Railway cars Nos. 125 and 126 were acquired in 1905, modified, and served until 1931 as the Loudon and Linden. Where they served makes the story both unique and a little macabre. The cars ran on a private streetcar line within Baltimore's Loudon Park Cemetery, where many of the city's more notable citizens are interred, including colorful writer H. L. Mencken. It is unclear whether this car was the Loudon or the Linden.

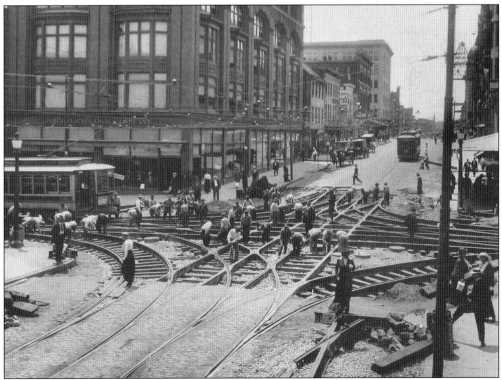

Looking west on Franklin Street toward Howard Street, the camera captured this image of extensive street and track work underway on June 20, 1914. Pedestrians had a tough go of it this day, and horse-drawn wagons had no choice but to detour around the intersection.

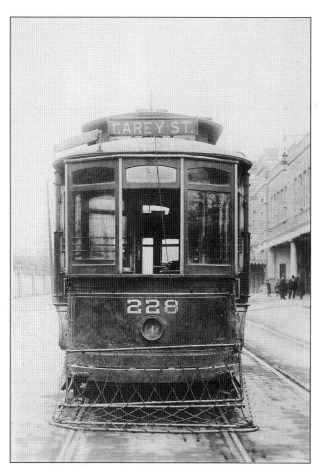

This *c.* 1918 photograph shows Brownell convertible No. 228 outside Park Terminal. Brownell began as a maker of horsecars and was founded as the Brownell and Wight Car Company in St. Louis in 1875.

Another early Charles Street bus, No. 14, featured inflatable tires, which no doubt made the ride between German (now Redwood) Street and University Parkway a little more comfortable. This shot was taken in 1916.

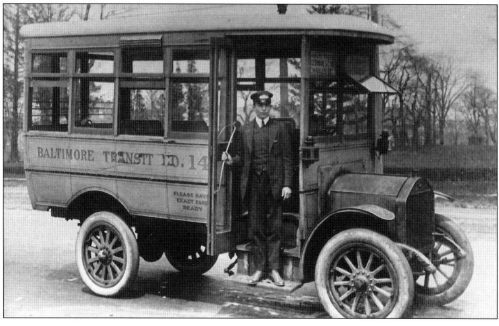

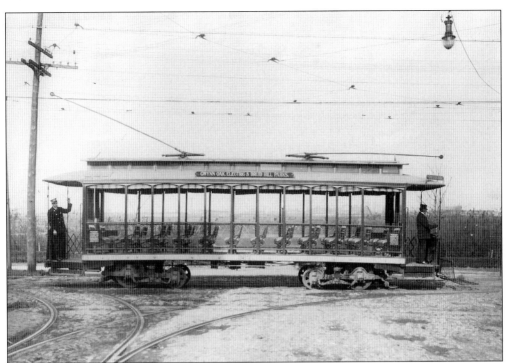

The United Railways and Electric Company apparently enjoyed taking publicity and archival photographs at their Carroll Park maintenance facility in southwest Baltimore off Washington Boulevard (then called Columbia Avenue). Taken sometime between 1907 and 1912, this photograph shows an American, 30-foot, wire-side open car, which was built in 1896 for the Pikesville, Reisterstown, and Emory Grove Railroad Company of Baltimore County. This car, No. 387, ran on the Gwynn Oak line until 1919. In 1902, the American Car Company was bought out by the J. G. Brill Company, which continued producing cars under the American banner until 1931.

This interior shot of No. 387 shows it spindle-back benches and center aisle. The wire-enclosed sides made it necessary for passengers to board and exit from the car-end platform rather than the running boards.

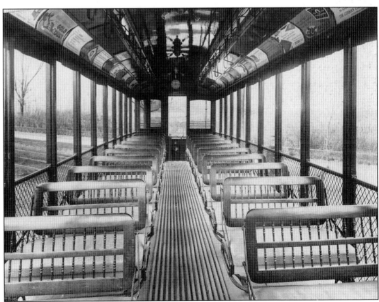

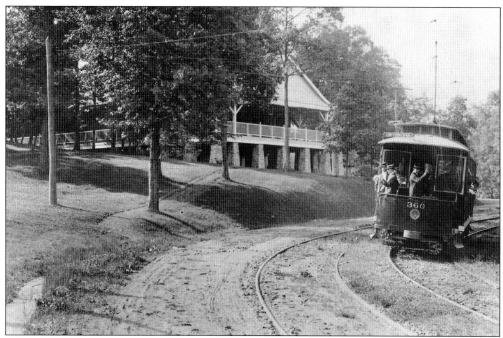

Car No. 360 is seen in this image rounding a curve at Gwynn Oak Park. The photograph was taken between 1910 and 1912.

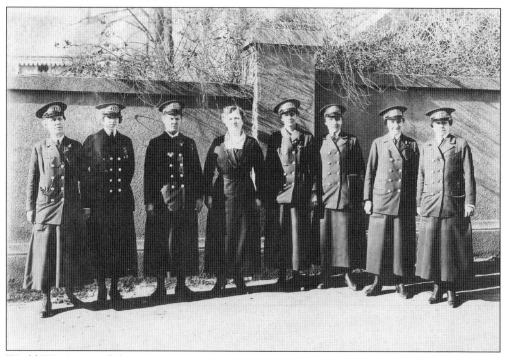

World War I created shortages in manpower throughout American businesses and industry. As a result, United hired its first female conductors in 1918. The women in this 1919 photograph are, from left to right, a Mrs. Dixon, a Miss Clouston, Eliza Slimbach, Anna Cook (supervisor), Frances Alder, a Miss Ambrose, a Mrs. Starbird, and Mary Cronin.

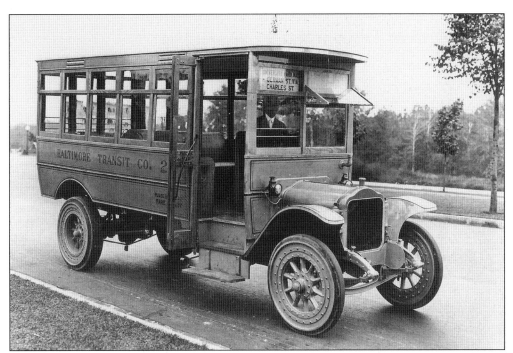

Charles Street bus No. 2 was another hard-rubber-tire model, this one manufactured by the White Motor Company, a firm that started out making sewing machines in Cleveland, Ohio, in 1876.

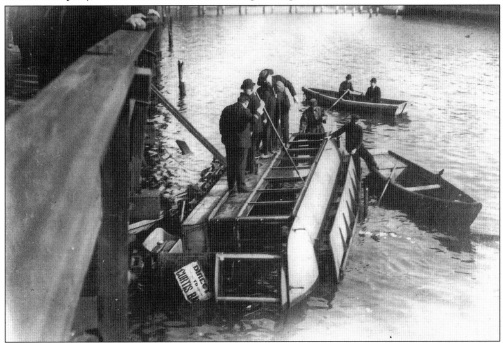

Although the sign reads "Direct to Curtis Bay," it is doubtful that passengers aboard No. 619 expected it to be this direct. On April 8, 1913, the car and its occupants tumbled off Long Bridge in south Baltimore and into the cold, murky water of the Patapsco River not far from its Curtis Bay destination. One passenger died.

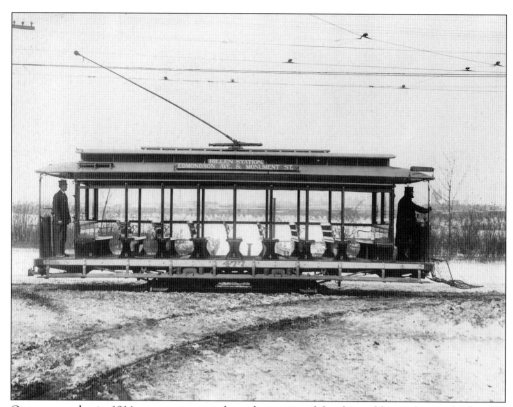

On a snowy day in 1914, a motorman and conductor posed for this publicity shot with No. 477, a Brill nine-bench open car that remained in summer service until 1919. It originally sported No. 186 for the Baltimore City and Suburban Railway when it arrived in Baltimore in 1895.

Here is an interior shot of No. 477, also from 1914. It was taken at Carroll Park. Vertical handles accommodated standees on the running boards.

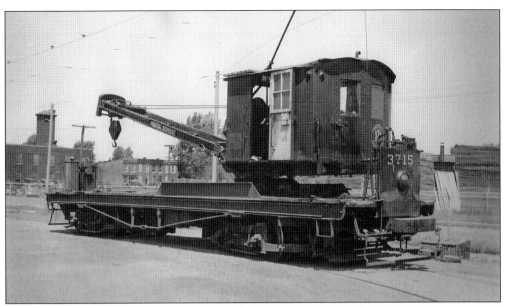

DT (double-trucked) flatcar crane No. 3715 was built in 1913. It was essential for railing and re-railing heavy streetcars. Today it is part of the working collection at the Baltimore Streetcar Museum. (Courtesy Maryland Department, Enoch Pratt Free Library.)

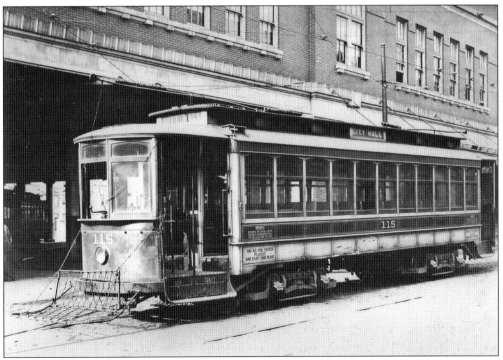

Car No. 115, a Brill semi-PAYE, arrived in January 1911 and seated 43 passengers. By the time it was scrapped in 1948, it wore No. 5394. This photograph was taken outside Park Terminal in 1911 or 1912.

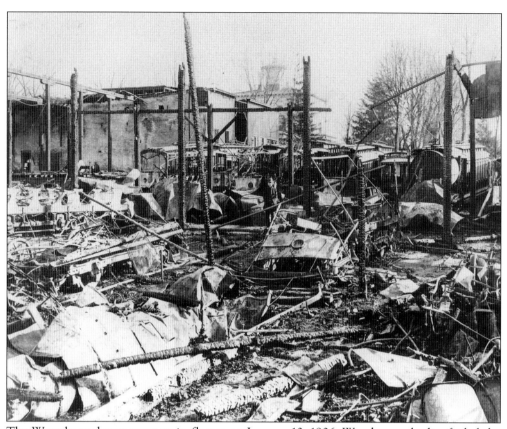

The Waverly car house went up in flames on January 10, 1906. Wooden car bodies fueled the fire, which consumed a total of 47 streetcars.

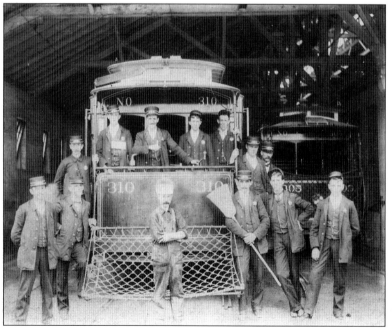

Cars Nos. 310 and 305 are pictured along with unidentified personnel at what is believed to have been United's Twenty-fifth Street facility. The photograph is undated.

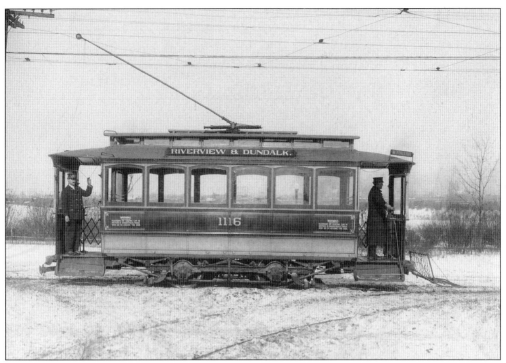

Originally purchased by Central Railway in 1897, car No. 1116 first wore No. 45. Built by Brill, it was 18 feet in length and featured single benches running lengthwise on each side of the car.

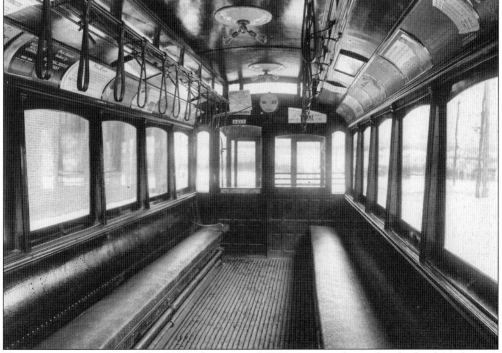

Here is an interior shot of No. 1116 taken around 1909. As a single-truck vehicle, the ride must have been a rough one, especially for standees.

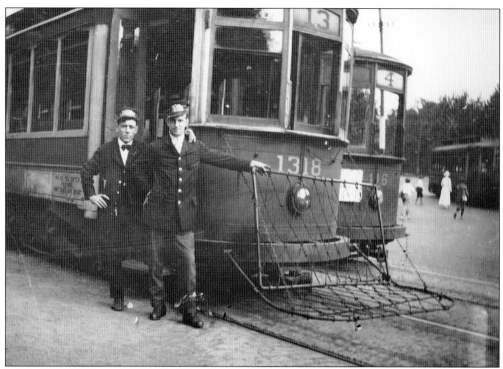

An unidentified conductor and motorman pose with car No. 1318 at Walbrook Junction in this shot taken in 1919. (Courtesy Maryland Department, Enoch Pratt Free Library.)

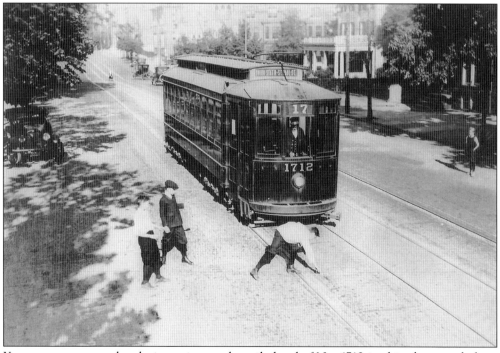

Youngsters appear to be placing coins on the rail ahead of No. 1712 in this photograph from May 12, 1919. It was taken at St. Paul and Thirty-first Streets.

Three

BRILLS, BIRNEYS, BUSES, AND BANKRUPTCY

The period from 1920 through World War II saw the expansion of bus service in Baltimore. Double-decked coaches debuted on the Charles Street "A" route, while open-bodied summer streetcars were permanently retired. Trackless trolleys also premiered during this period, operating first between Gwynn Oak Junction and Randallstown along Liberty Road. A new single-truck streetcar, dubbed a Birney, first came on the scene. Intended to reduce operating expenses since it needed no conductor, the Birneys were one of the biggest busts in company history for the United Railways and Electric Company. Passenger congestion at the single narrow door slowed their operation, wooden slat seats were uncomfortable, and the single truck caused them to rock like a child's hobbyhorse. Nine years after purchasing them, United dumped the Birneys in 1929.

United-owned Riverview Park on Broening Highway passed into history in 1927 to accommodate a huge new facility for Western Electric. Three years later, another new kind of streetcar began to arrive. The Peter Witt cars were made of steel, and they were big—46 feet long to be precise. Two-man cars, the Witts got their name from a Cleveland, Ohio, transit official who devised and patented a new system of fare collection. Two test units had been operating over Baltimore streets since 1924 but were unpopular with motormen, who deemed them slow and cumbersome. Nevertheless, United bowed to public demand for new cars (their last order was in 1919) and purchased 150—100 from the J. G. Brill Company and 50 from the Cincinnati Car Company—at a total cost of more than $2.5 million. By the time these orders were placed in 1929, the Witts were lighter and faster, and could be operated without a conductor, so the term "Peter Witt" really no longer applied, but it stuck.

Something else that stuck was the red ink on United's ledgers. Already cash strapped, United was facing $8 million in bond obligations due between 1929 and 1932. On January 6, 1933, the company declared bankruptcy. Reorganized, it emerged in 1935 with $50 million in new capital and a new name, the Baltimore Transit Company.

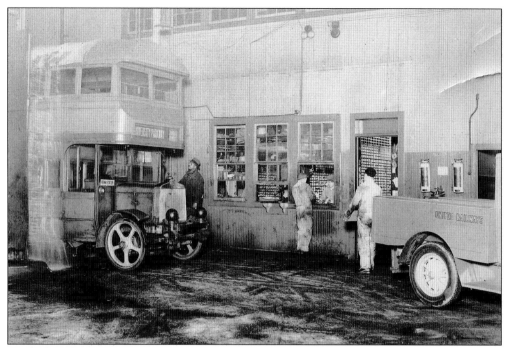

Inside the Charles Street garage on December 19, 1928, bus No. 112 (at the left) gets a bath while employees make a pick up or delivery at the storeroom window.

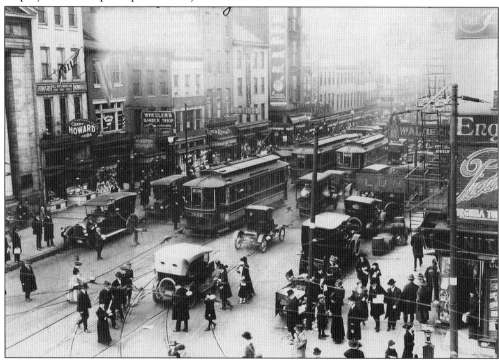

Traffic, what traffic? That could be the subtitle for this 1936 photograph that captures car No. 1059 and others making their way through the busy intersection of Howard and Lexington Streets, which at the time was the heart of Baltimore's retail district.

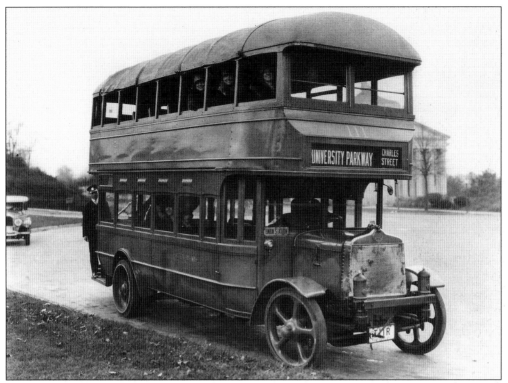

A few brave, smiling souls dare to face the winter weather in the upper deck of bus No. 111, which is still sporting hard-rubber tires. The bus appears to have been near Charles and Twenty-ninth Streets when this 1927 photograph was taken.

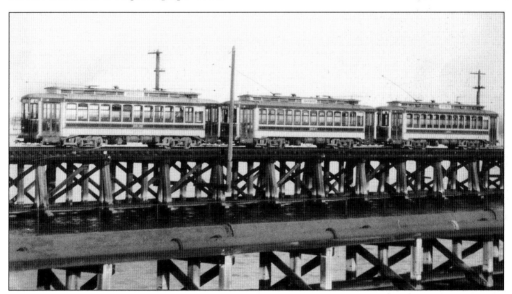

Multiple Units, or MUs, were the norm on the busy Sparrows Point line, which transported employees to and from the massive Bethlehem Steel plant there. In this 1920 shot, semis Nos. 2639, 2647, and 2635 are captured crossing the bridge over Bear Creek, which connected Dundalk with "the Point." Locals affectionately called the Sparrows Point MUs "the Red Rocket."

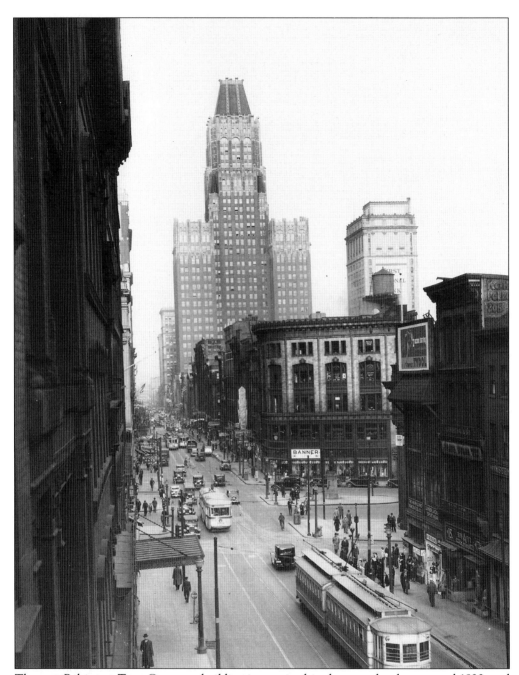

The new Baltimore Trust Company building is seen in this photograph taken around 1930, and for decades, it was the city's tallest skyscraper. In the right foreground, articulated cars head east at West Baltimore and Liberty Streets, while Peter Witt car No. 6013 prepares to pass them going west. Today the First Mariner Arena occupies the land shown in the lower right corner of this photograph.

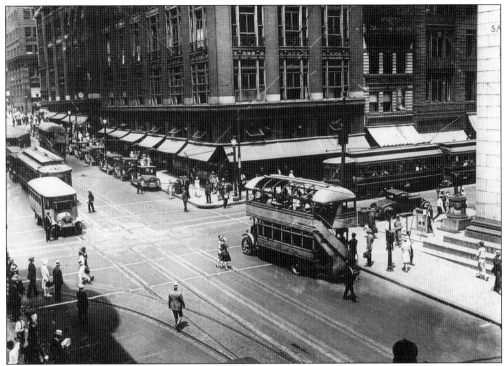

A plethora of United Railways equipment converges on the intersection of Charles and Baltimore Streets in this 1924 picture. Double-decked bus No. 105 was headed north on Charles behind a second double-decker. Southbound, a semi-convertible on the No. 25 line waits behind a single-level bus. Meanwhile an articulated streetcar waits on East Baltimore Street at the right.

Named for Charles O. Birney, the engineer who designed them, Birney cars were intended to save transit lines money because no conductor was needed. Small and lightweight, they also featured just one truck, or set of wheels. "They rocked up and down terribly," recalled Bob Janssen, a Baltimore Streetcar Museum volunteer who rode the Birneys during their short tenure in Baltimore. Unpopular with riders, Birney cars lasted just nine years in the city, from 1920 to 1929.

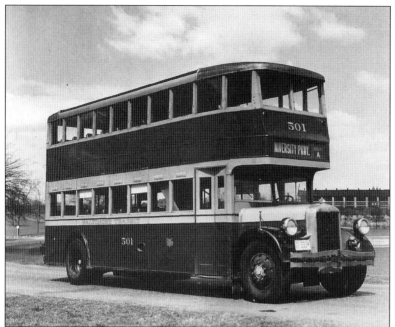

Built in 1930 by Yellow Coach of Pontiac, Michigan, bus No. 501 seated 69 passengers, 40 up top and 29 on the bottom, and, like all of Baltimore's double-decked coaches, operated almost exclusively on Route A along Charles Street. It was scrapped in 1945.

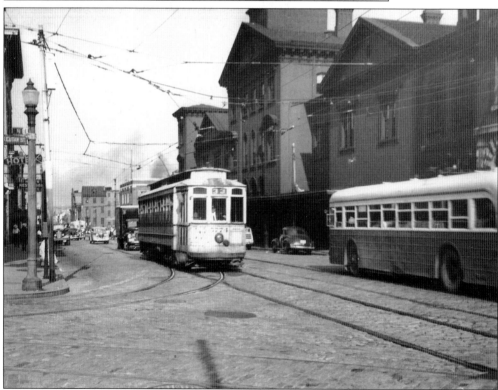

Semi No. 5774 was on the No. 33 line and was about to pass a trackless trolley on Camden Street at Eutaw when this photograph was snapped in the 1930s. The large building at the right is Camden Station, which opened in 1856 and today is the home of the Sports Legends Museum at Camden Yards.

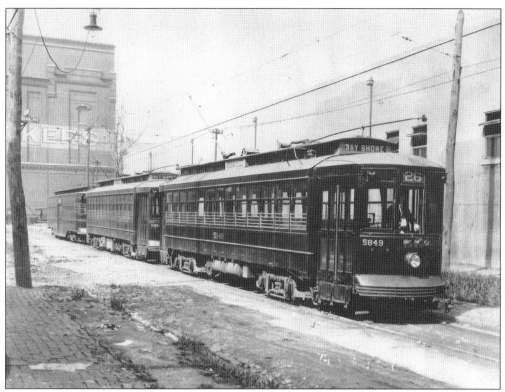

Cars Nos. 5849, 5864, and a trailer prepare to depart the Highlandtown car house en route to Bay Shore Park in Edgemere in this picture made on September 17, 1927. The United Railways and Electric Company owned Bay Shore Park at the time. The Highlandtown car house remains today and has been converted to senior housing.

Bus No. 102, seen here in the 1920s, is another example of the double-decked coaches that traversed Charles Street between 1915 and 1942.

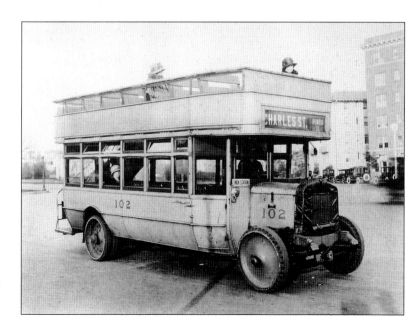

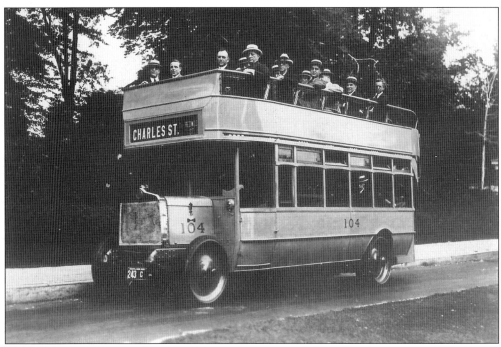

The weather was warmer when No. 104 was photographed along Charles Street in 1922. United officials, a few looking less than enthused, are the passengers.

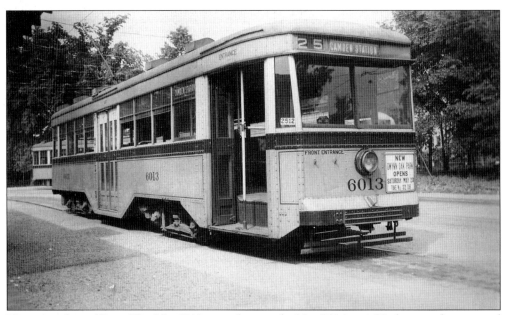

This great shot of Peter Witt No. 6013 was taken on the No. 25 Mount Washington line around 1939. Stylistically, the Witts served as a bridge between the old semis and the President's Conference Committee (PCC) cars yet to come. (Photograph by Burridge Jennings, courtesy Maryland Department, Enoch Pratt Free Library.)

The Middle River car house was in rough shape when this undated photograph was snapped. Situated on Eastern Avenue at Moffitt Avenue, it was about a half mile east of present-day Eastpoint Mall. Streetcar service to Middle River was replaced by buses in 1942.

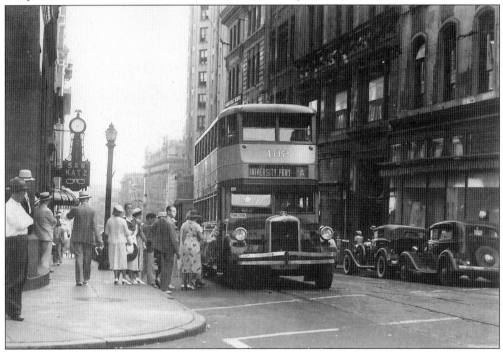

A later version of bus No. 102 is the subject of this *c.* 1940 picture as it picks up passengers at Charles and Lexington Streets. Then as now, it seems Baltimore bus drivers had an aversion to pulling all the way into the curb, much to the frustration of trailing motorists.

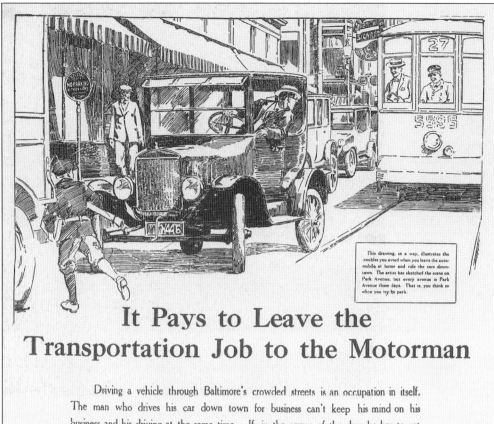

This drawing, in a way, illustrates the troubles you avoid when you leave the automobile at home and ride the cars downtown. The artist has sketched the scene on Park Avenue, but every avenue is Park Avenue these days. That is, you think so when you try to park.

It Pays to Leave the
Transportation Job to the Motorman

Driving a vehicle through Baltimore's crowded streets is an occupation in itself. The man who drives his car down town for business can't keep his mind on his business and his driving at the same time. If, in the course of the day, he has to get around a good bit he discovers that the time spent in finding a place to park his car has left little time for business. Sooner or later he relies on the street cars as the safest, cheapest and most convenient way of getting around town. It pays to leave the transportation job to the motorman and

Ride the Cars

This United advertisement and others like it ran in Baltimore newspapers during 1926. The pen-and-ink drawings were created by a local portrait painter, Willem Wirtz. Today his son, Paul Wirtz, is a Baltimore Streetcar Museum volunteer.

Tokens, also called car checks, were introduced as a means to speed up the collection of fares. Purchased in advance, the rider got a small break on the price, not unlike the concept of today's E-Z Pass for motorists using toll roads.

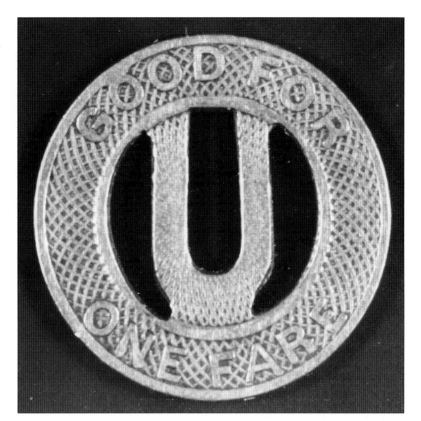

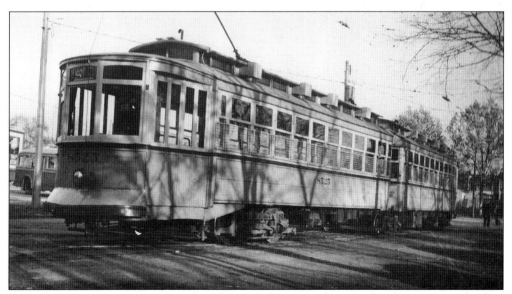

Articulated streetcar No. 8525 is the subject of this 1939 photograph taken at the Belvedere loop. Articulated units were the result of modifications of older streetcar bodies. The work was performed at the Carroll Park facility. (Photograph by Burridge Jennings, courtesy Maryland Department, Enoch Pratt Free Library.)

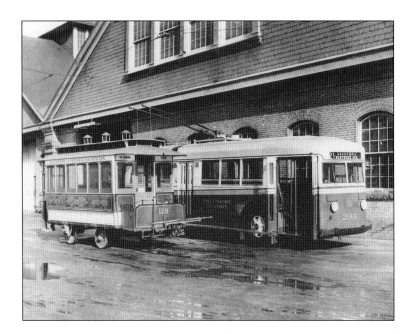

This 1938 shot was taken at Carroll Park. Horsecar No. 129 is posed alongside trackless trolley No. 2001, apparently to illustrate how far Baltimore's transit system had come in 80 years. (Courtesy Maryland Department, Enoch Pratt Free Library.)

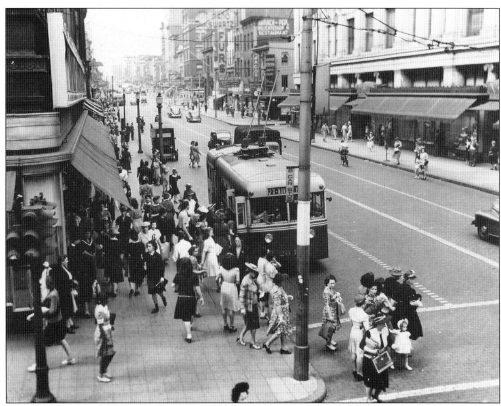

Trackless trolleys replaced streetcars on the No. 27 line on December 31, 1938. In this undated photograph, one of the electric buses, referred to by some as a trolley coach, stops at Howard and Lexington Streets where streetcar tracks have already been paved over.

BALTIMORE TROLLEY TOPICS

PUBLISHED MONTHLY FOR THE EMPLOYES OF THE UNITED RAILWAYS AND ELECTRIC COMPANY

VOL. 9　　　　BALTIMORE, MD., JULY, 1925　　　　**NO. 7**

Electric Railways Are Forty Years Old

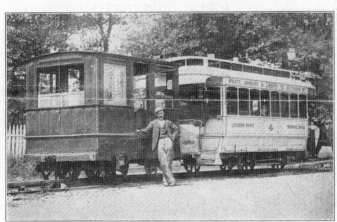

Baltimore and Hampden Electric Train of 1885

THE first commercially operated electric street cars in America were those of the Baltimore and Hampden Line, a third-rail system, which began operation August 10th, 1885.

At road crossings, after the bared third rail had proved shocking to horses drawing vehicles across the tracks, an overhead trolley device was rigged up. A crude trolley pole was attached to the tops of the cars, and this was raised to contact with the wire at the crossings. Throughout the remainder of the run the power was taken from the third rail.

The first thoroughly equipped overhead trolley line in America was established in Richmond, Va., in 1887.

Baltimore's first overhead line was on North avenue, from Division to Tenth street, started August 16th, 1890.

In connection with the fortieth anniversary of Baltimore inaugurating electric railway service in America, we are printing on Pages 10 and 11

(Continued on Page 4)

Baltimore Trolley Topics was a monthly employee publication of the United Railways and Electric Company. This edition from July 1925 commemorates the 40th anniversary of the electric streetcar in Baltimore.

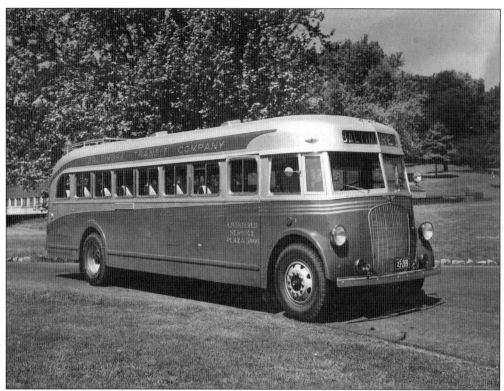

ACF Brill Bus No. 1 sits for this formal shot in Carroll Park during 1938. ACF Brill was the end result of a 1926 takeover of the J. G. Brill Company by the American Car and Foundry Company.

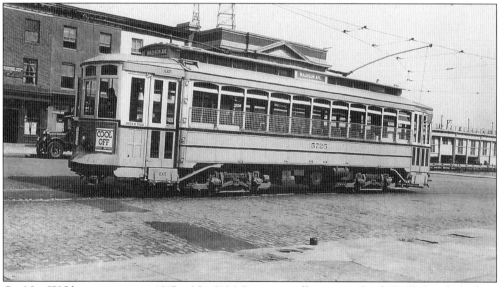

Car No. 5725 began service in 1917 as No. 3126. It is an excellent example of a Brill closed-platform semi-convertible. The closed platform afforded the motorman some protection from the elements. Car No. 5725 was scrapped between 1947 and 1949. In this c. 1930 photograph, it stands in Fells Point at the foot of Broadway. (Courtesy Marian Zych.)

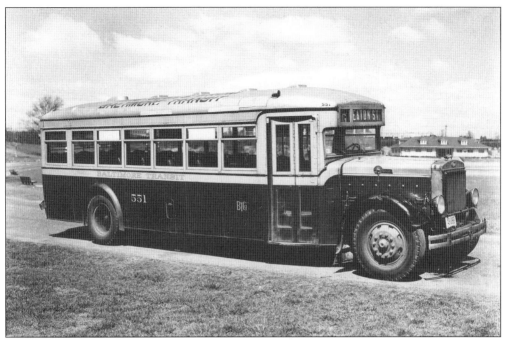

This picture, from 1939 or 1940, shows bus No. 551, made by Mack and assigned to the G route. It was photographed in Carroll Park.

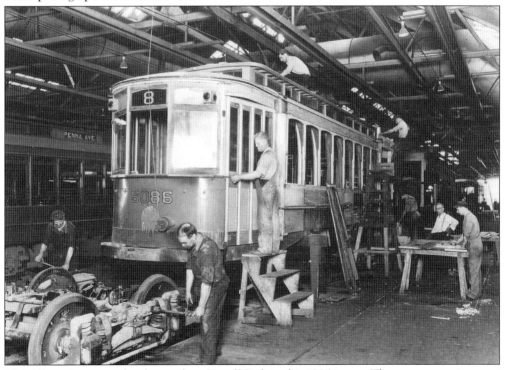

United's craftsmen are hard at work at Carroll Park in this 1926 image. They are converting semi No. 5086 into an articulated. The articulated seated 87 passengers and was an innovative way to increase capacity while salvaging old car bodies and materials.

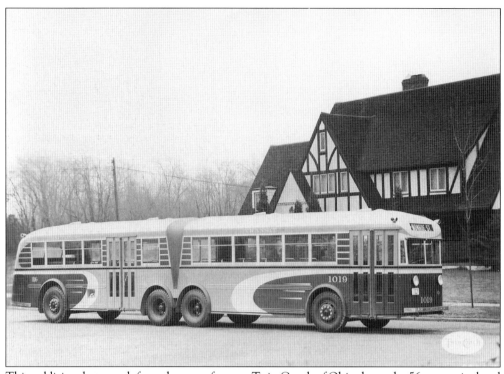

This publicity photograph from the manufacturer Twin Coach of Ohio shows the 56-seat articulated bus that Baltimore Transit bought in 1938. Costing $17,088.70, it was dubbed the "Queen Mary" by locals.

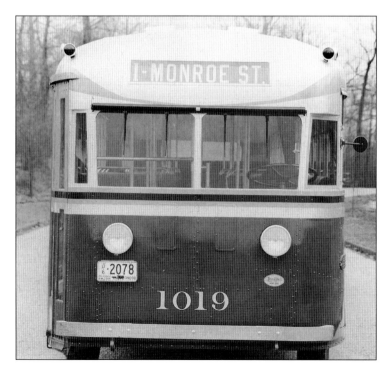

Articulated bus No. 1019, although painted in the Baltimore Transit Company colors and displaying a Baltimore route sign, still had an Ohio license plate when this 1938 photograph was taken.

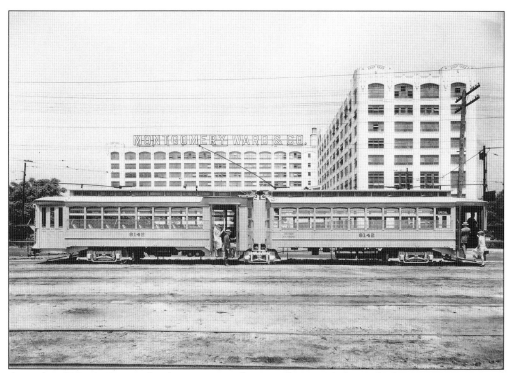

Articulated No. 8142 poses for this company photograph in 1926 alongside the Montgomery Ward building at Washington Boulevard and Monroe Street.

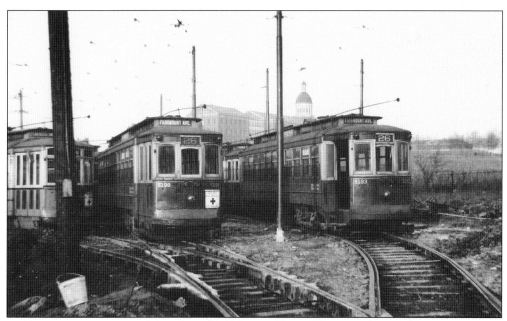

Brill semis Nos. 5198 and 5193 were first out in the Oldham Street yard in this undated photograph. The former Bayview Asylum on Eastern Avenue, now Johns Hopkins Bayview, is visible in the background. Interstate 895 (the Baltimore Harbor Tunnel Thruway) runs through this spot today.

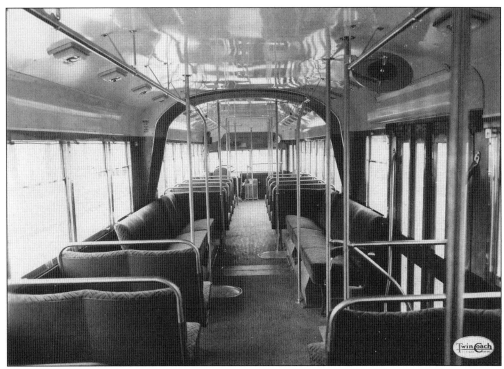

This interior shot of articulated bus No. 1019 looks from the rear toward the front. The No. 1019 worked better in theory than in practice and was scrapped just a few years after being purchased in 1938.

This 1940 photograph features the gasoline-powered, 18-passenger bus No. 588. It was made in 1933 for United by Twin Coach.

Semis Nos. 5812 and 5798 rest in the Overlea loop on Belair Road in this 1925 photograph. Eventually, the tracks for the No. 15 line would be relocated to the center of the street.

Bus No. 508 was southbound on Charles Street at Baltimore Street alongside what was then the Baltimore and Ohio Railroad headquarters when this 1940 photograph was taken.

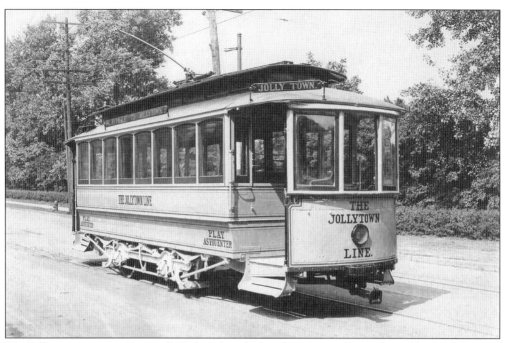

The Jollytown car was a Brownell 20-foot, 9-inch closed car originally purchased by the Baltimore Consolidated Railway in 1898 and christened car No. 134. In 1922, it was assigned to Gwynn Oak Park as a children's attraction where boys and girls were instructed to "Play As You Enter."

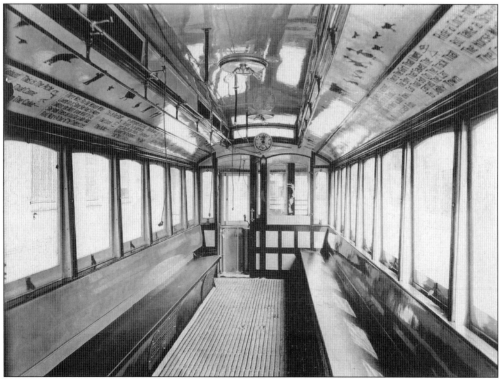

Inside the Jollytown car, advertisements were replaced by nursery rhymes and images of animals.

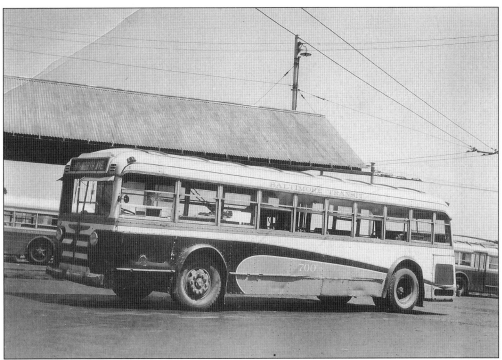

Bus No. 700 was manufactured by Yellow Coach. It was at Baltimore Transit's Potomac Street facility when this photograph was taken around 1940.

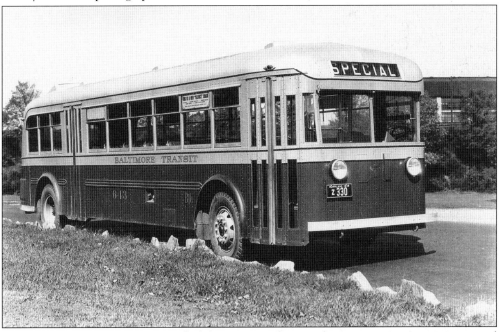

The Baltimore Transit Company called this unit a viaduct coach, promoting more seats, improved ventilation, better lighting, and similar passenger amenities. Bus No. 643 was made by Ohio's Twin Coach. The viaduct fleet was employed in areas where streetcar tracks were prohibited, like the then-new Bath (Orleans) Street viaduct. The picture is from 1936.

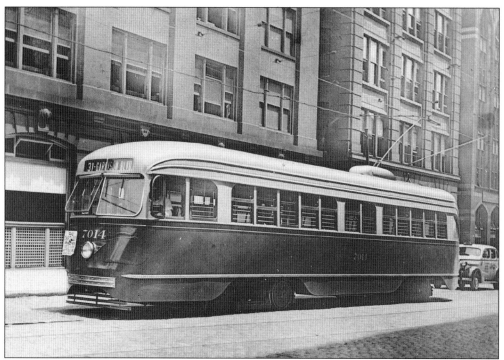

Arguably the most attractive transit vehicles in Baltimore were the PCC cars. Introduced in 1936, they were named for the President's Conference Committee, a group of industry officials who designed them. (Courtesy Maryland Department, Enoch Pratt Free Library.)

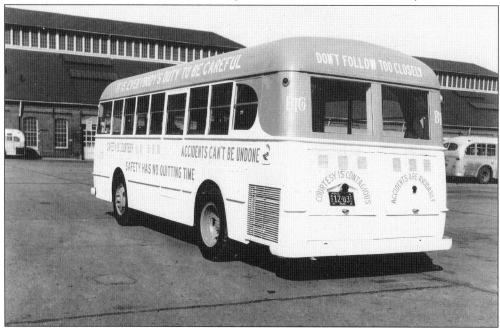

Advertisements have long adorned the outsides of public transit vehicles. Sometimes public service messages were depicted too, like the safety messages found on this Baltimore Transit Company bus in 1940.

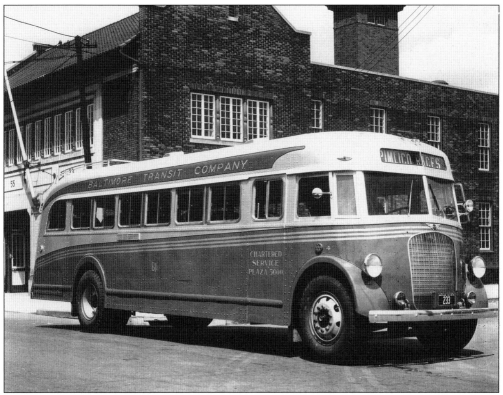

Bus No. 4 by ACF Brill was, by virtue of its route sign, off to the races when this image was captured by a photographer in the 1930s.

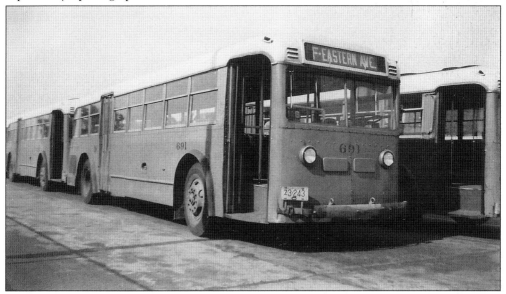

This 1950 photograph depicts yet another Baltimore Transit Company bus model, the TG-3201, made by the Yellow Truck and Coach Manufacturing Company. General Motors bought a majority share of Yellow in 1925 and purchased the company outright in 1943 but continued to manufacture vehicles under the Yellow nameplate until 1944.

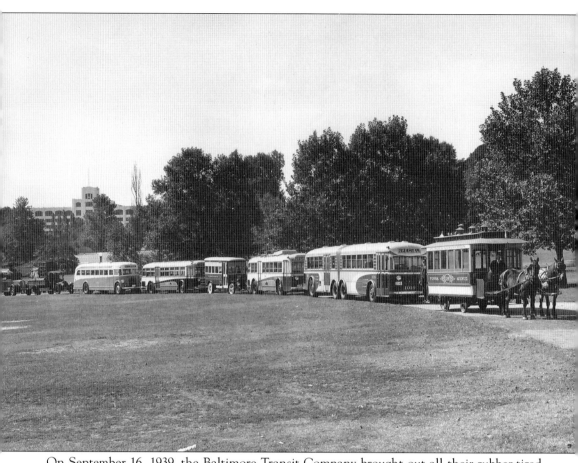

On September 16, 1939, the Baltimore Transit Company brought out all their rubber-tired vehicles, both past and present, for an event called "Wheels of Progress." Included in the group was horsecar No. 129, which was fitted with rubber tires for just such occasions. The photograph was taken in Carroll Park.

Four

WORLD WAR II

As the 1930s gave way to the 1940s, more and more streetcar lines were converted to bus or trackless trolley lines. PCC (President's Conference Committee) cars were on the scene by now, and the public was somewhat smitten with them. Purchased first from the St. Louis Car Company then later Pullman-Standard, the PCCs may have been the most attractive and smoothest-riding cars ever. Decked out in an attractive color scheme chosen by students at the Maryland Institute College of Art, the PCCs featured a silver-gray roof, Alexandria blue (actually a deep green) lower body, and a cream top half. The top and bottom halves were separated by an orange belt that wrapped around the entire car. Its single headlight was accented by an attractive set of silver wings. The PCC car was art deco at its best and, as fate would have it, the last streetcar ever ordered by the Baltimore Transit Company.

Still on the streets were many of the old Brill semis from the first decade of the 20th century. After the United States became involved in World War II on December 7, 1941, even more of the old wooden cars—some in storage for a decade or more—were forced back into service. Shortages in rubber products and fuel, plus defense-related employment at Bethlehem Steel in Sparrows Point and Bethlehem's Fairfield Shipyard, caused a spike in streetcar ridership. Extra buses were needed between the city and the Glenn L. Martin aircraft plant in Middle River (the No. 23 streetcar line from Highlandtown no longer went that far down Eastern Boulevard). To the delight of company officials, the Baltimore Transit Company was in the black again, but they learned shortly after World War II ended that the celebration would be short lived.

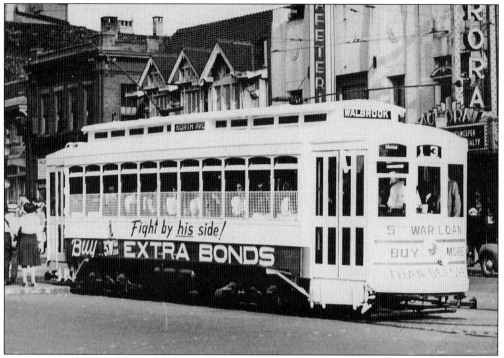

At westbound North Avenue near Charles Street, semi No. 5632 sported a special paint job during 1944. Baltimore Transit Company vehicles became important instruments for morale during World War II, motivating citizens to enlist, donate money, give blood, and more.

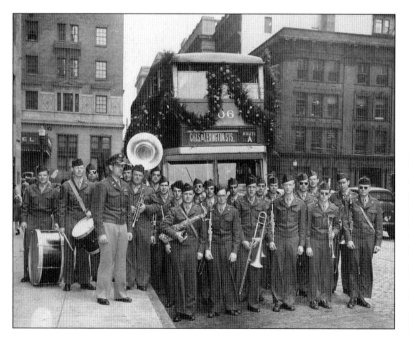

With the old Southern Hotel at Light and Redwood Streets in the background to the left, a military band poses for a photographer in front of a decorated Route A double-decked bus c. 1942.

They were not assigned combat duties back then, but the U.S. Marine Corps Women's Reserve carried out myriad support functions during the war. This unidentified trio poses with a PCC car near the intersection of Pratt and South Streets around 1943.

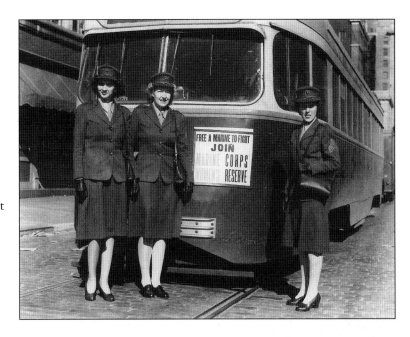

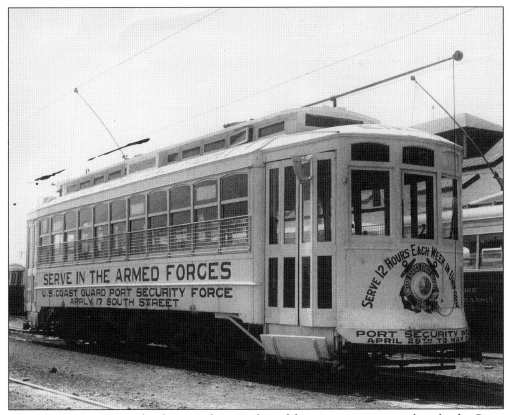

That is semi No. 5628 under the special paint job used for recruiting new members for the Coast Guard Port Security Force in 1945.

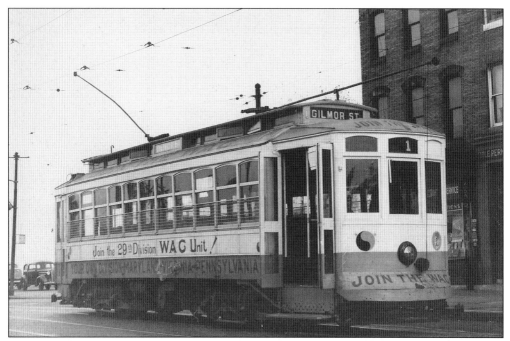

A year earlier, No. 5628 was recruiting for the local Woman's Army Corp. Operating over the No. 1 line, it was photographed at Twenty-fifth Street and Greenmount Avenue.

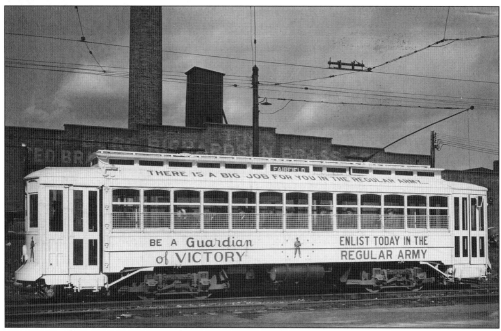

Here is No. 5766 at Monument and Kresson Streets calling for men to join the U.S. Army. While there was no shortage of patriotism during World War II, it is really impossible to say what, if any, impact the specially painted cars had on the war effort. If nothing else, it was a noble gesture on the part of the Baltimore Transit Company.

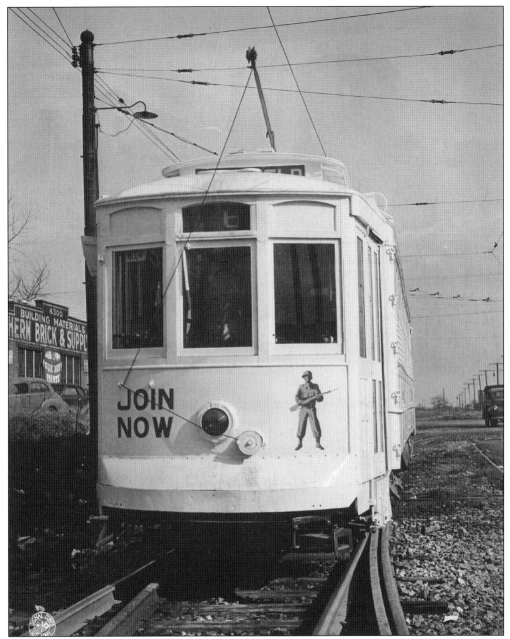

The No. 5766 is seen here from another angle. Baltimore Transit Company painters were public-spirited craftsmen who wanted their mobile canvases to look their best, regardless of the company's frugal nature.

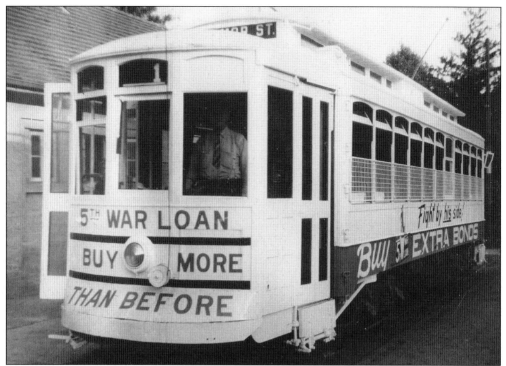

This is a closer look at No. 5632, taken in June 1944. Built in 1914, the No. 5632 served 33 years, until 1947.

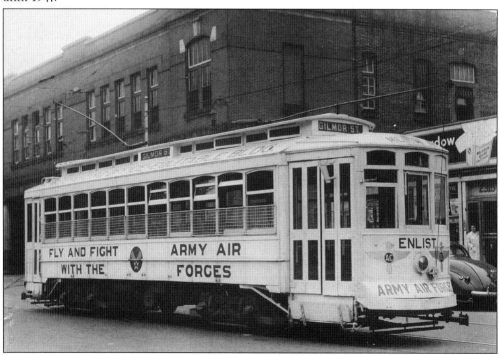

Here is the No. 5632 again, wearing yet another special paint job. This time it is recruiting for the U.S. Army Air Force during 1944.

On this occasion, the camera found semi No. 5766 getting the once-over in the Baltimore Transit Company paint shop. While no one today is absolutely certain, it is believed that the Baltimore Transit Company absorbed the cost of the labor and materials used to modify these billboard cars as a public service.

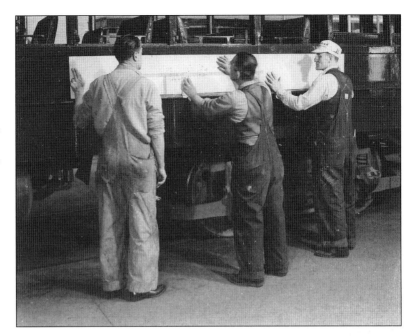

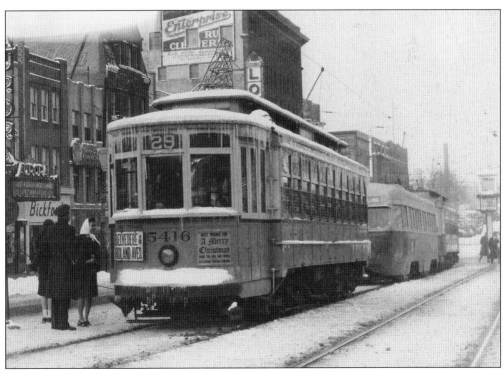

Outside the old Aurora Theatre, icicles hang from semi No. 5416 as it pauses to pick up passengers on a snowy day during the war years. A PCC car and a second Brill unit wait behind.

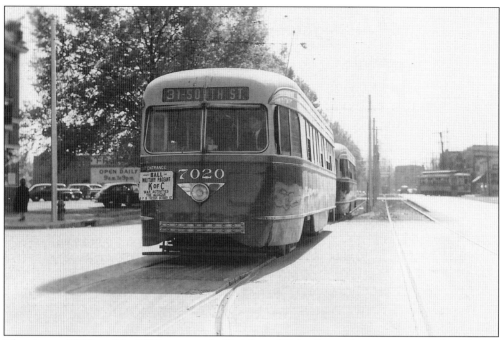

The sign on PCC car No. 7020 promoted a Knights of Columbus military pageant at the Alcazar on Cathedral Street when this photograph was taken at the Belvedere loop in October 1943.

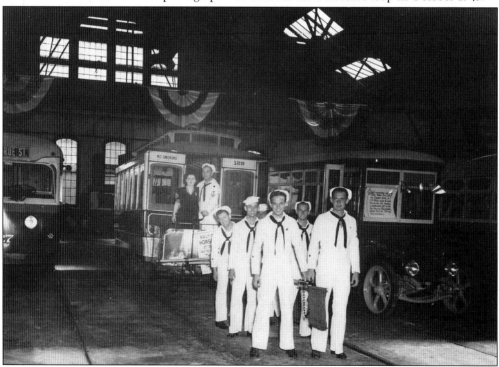

Surrounded by vintage vehicles at the Carroll Park shops, six sailors fill in for horses while a lucky seventh gets the girl on the old No. 129 horsecar. The 1915 bus on the right is on display today in the History and Technology Building of the Smithsonian Institution in Washington, D.C.

The finished product on this occasion is a mobile recruiting billboard for the U.S. Marines. Car No. 5766 first hit the streets of Baltimore in 1918 as No. 1522 and operated until 1948.

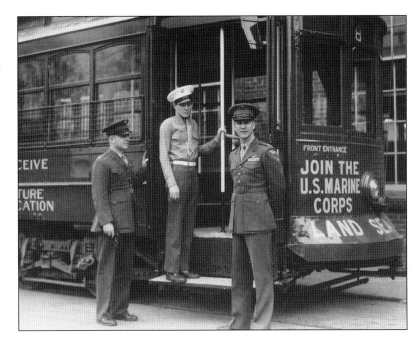

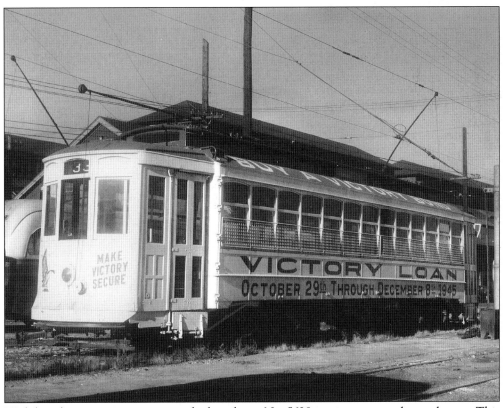

With less than a year remaining in the hostilities, No. 5628 receives yet another makeover. This time it is to promote the Sixth War Loan Drive in 1944.

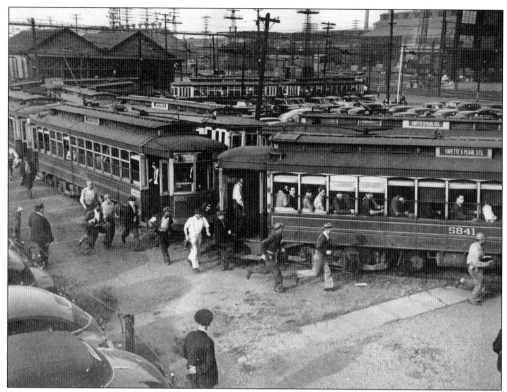

The race is on for the ride home aboard a fleet of semis at the Bethlehem Steel shipyard loop in Sparrows Point. Increases in defense-related employment here and at other facilities, like the Glenn L. Martin aircraft plant in Middle River and Bethlehem's Fairfield Shipyard, taxed the resources of the Baltimore Transit Company. Mothballed cars the company could not sell because of the Baltimore Gauge were returned to active duty. (Courtesy Dundalk–Patapsco Neck Historical Society Museum.)

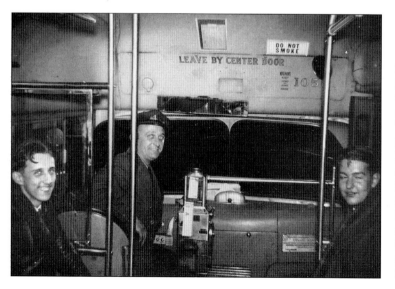

Rubber, metal, and fuel shortages during the war impacted the Baltimore Transit Company too. On December 28, 1942, the last bus ran on the Charles Street A Route, the city's oldest bus line. At the wheel of Yellow Coach bus No. 1058 that evening was Charles Rogers (center).

Five

ONE LAST HURRAH
1946–1970

According to testimony presented to the U.S. Senate in 1973, the National City Lines (NCL) was a holding company funded by Firestone Tire and Rubber, Standard Oil of California, Phillips Petroleum and, last but definitely not least, General Motors (GM) for the express purpose of acquiring and dismantling urban streetcar operations. In so doing, they allegedly created lucrative and long-term markets for their own products. Between 1936 and 1950, NCL acquired private transit systems in cities such as New York, Philadelphia, Detroit, and Los Angeles—more than 100 systems in all in 45 American cities. In 1944, their affiliate, the American City Lines, acquired 30 percent of Baltimore Transit Company (BTC) stock, enough to get two seats on BTC's board of directors. When BTC president Bancroft Hill retired in 1945, Fred A. Nolan, who had worked for NCL in both Chicago and Los Angeles, became company president. In no time, a modernization program was ordered. At its core was the elimination of fixed-wheel vehicles, long considered by some to be a transit impediment.

Politicians facilitated the process. Baltimore city officials were busy planning the conversion of a number of streets used by streetcars to one-way operation while Maryland state leaders were salivating at the thought of increased tax revenue from the additional gasoline and diesel fuel that would be consumed. Before long, BTC president Fred Nolan had placed orders for hundreds of new GM diesel and ACF Brill gasoline buses. While Nolan failed to live to see the changes he orchestrated take effect, his successor, Claude Gray, another long-time NCL man from St. Louis, Missouri, did. In a mysterious twist, Gray took his own life on February 1, 1948.

With the 1950s came cheap gasoline, more automobiles, fewer streetcars, and in 1959, the end of trackless trolley service. New air-conditioned GM buses arrived in 1963. On November 3 of that same year, Baltimore's last streetcar, PCC No. 7407, made its final run. Operation of city buses was assumed by the state's Mass Transit Administration on April 30, 1970, and the BTC was officially liquidated in 1975.

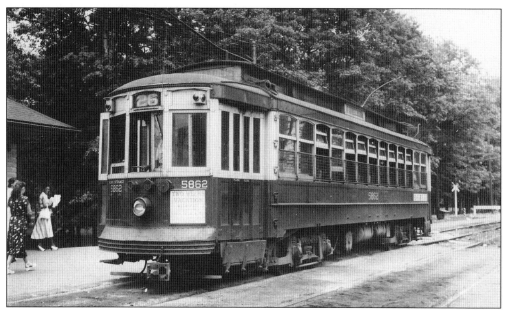

Semi No. 5862 waits at the Sparrows Point loop in this photograph from July 16, 1949. Despite the fact that employment at Bethlehem Steel's Sparrows Point plant had not yet reached its peak, the need for mass transit fell off sharply as gasoline, rubber, and other materials relating to the private automobile could now be had in abundance.

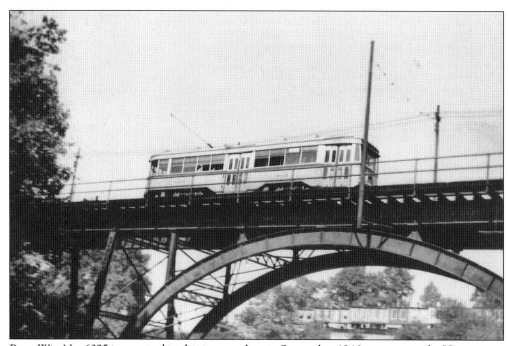

Peter Witt No. 6025 is captured in this image taken in September 1946 as it crosses the Huntington Avenue bridge on the No. 25 line en route to Camden Station.

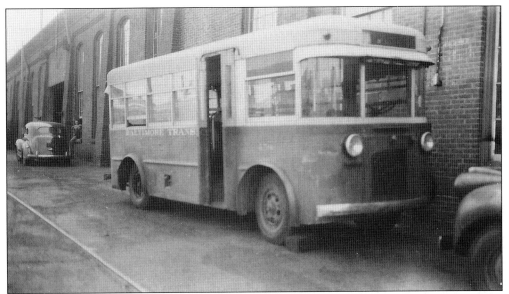

Twin Coach bus No. 459 appeared to be ready for the scrap yard in this 1946 photograph taken at Carroll Park. On closer examination, it had been converted into a service vehicle.

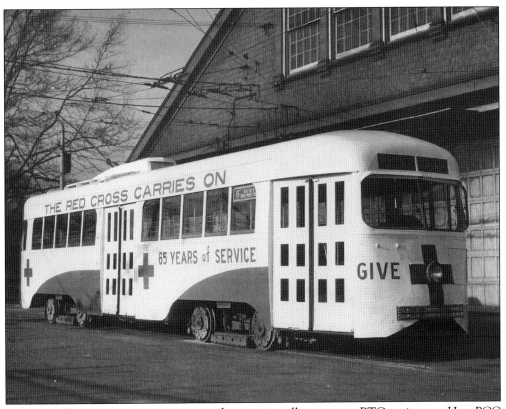

Post-war public service messages continued to occasionally pop up on BTC equipment. Here PCC No. 7389 is all decked out in red and white on behalf of the 1946 Red Cross blood drive.

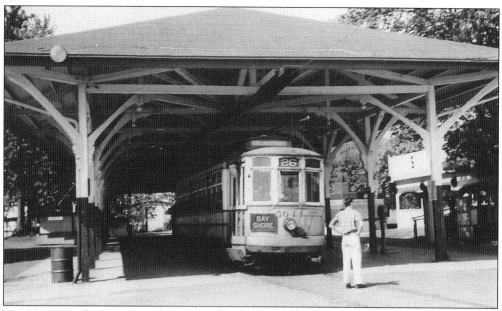

No. 5644 is catching some shade at Bay Shore Park in this late-1940s image. United/BTC owned Bay Shore until 1943, when it was sold to one-time racing commissioner and perennial political candidate George P. Mahoney, who later sold it to a commercial realtor. In 1946, Bethlehem Steel bought the property to accommodate a proposed expansion. Bethlehem closed Bay Shore in 1947, but the expansion never occurred. Today it is North Point State Park, and the restored streetcar station is all that remains of the original park.

Ford 69-B bus No. 1250 was the subject of this 1949 photograph. One of 100 ordered in 1946, the small bus seated 27. Unpopular with riders, the Fords were phased out in the early 1950s.

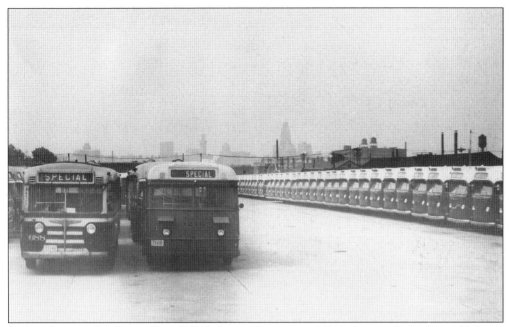

In this photograph taken at Carroll Park during the winter of 1948, dozens of new General Motors buses awaiting their first assignment are lined up at the right like statues. In the foreground at left are the older Yellow Coach No. 688 and Ford No. 1210.

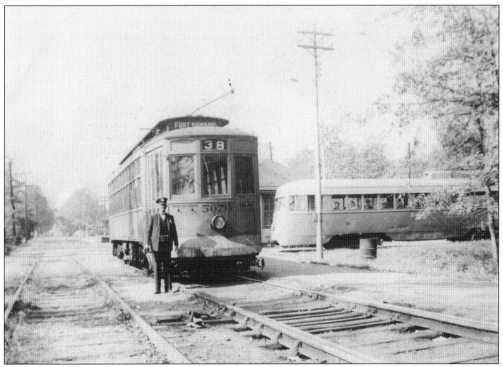

Semi No. 5679, bound for Fort Howard, and PCC No. 7139 are photographed at the Sparrows Point loop around 1953. Direct service between Fort Howard and Bay Shore was disrupted in 1933 after a hurricane destroyed a bridge along the route.

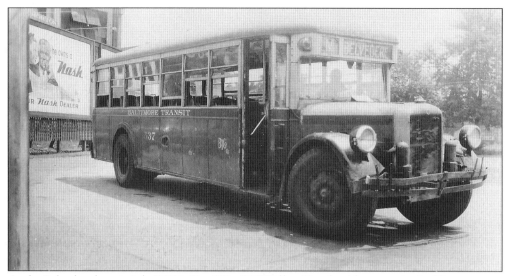

At the Belvedere loop in July 1946 is No. 537, a 1931 Yellow Coach with a capacity for 33 passengers. The billboard partially visible at the left rear promotes that year's new Nash automobile.

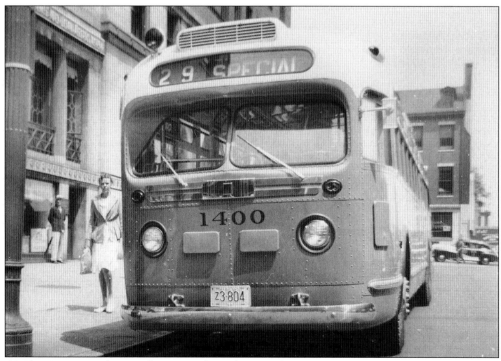

GM bus No. 1400, shiny and new, caught a photographer's eye at St. Paul and Fayette Streets on June 21, 1947.

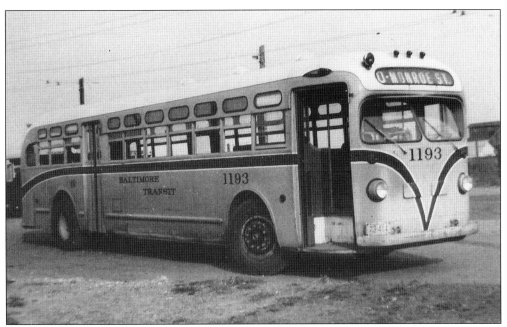

What many consider the classic city bus, the GM TD-4506, arrived in Baltimore in 1946. Bus No. 1193 sports a lemon-yellow colored body, a white roof, and a blue accent stripe.

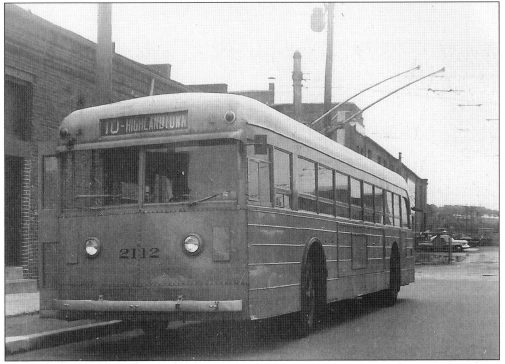

Trackless trolley No. 2112 was made by Pullman-Standard in 1942. Called a trolley coach or trolley bus by some, trackless trolleys operated on Baltimore streets until the summer of 1959, about the time this photograph was taken at Pratt and Grundy Streets in Highlandtown. (Courtesy Marian Zych.)

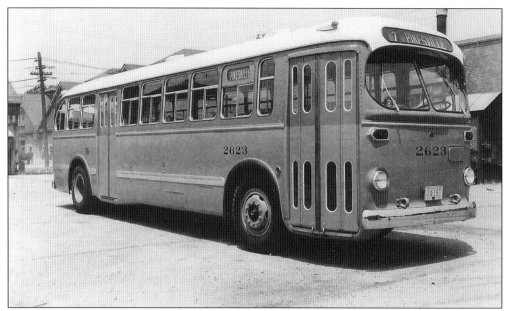

Bus No. 2623 was manufactured by ACF Brill and, unlike most buses, ran on gasoline instead of diesel fuel. It was one of 160 to join the BTC fleet in 1947. When this photograph was taken in 1949, No. 2623 sported the so-called "fruit salad" look of National City Lines—a gray roof, lime green top half, and yellow bottom. Most BTC vehicles wore this color scheme for only a short period, changing to transportation yellow in 1949.

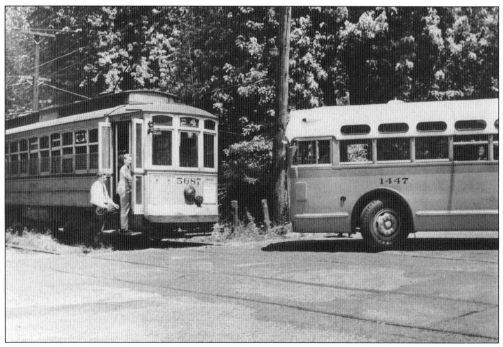

GM bus No. 1447 and semi No. 5687 are nose-to-nose in this 1947 photograph taken on the No. 24 Lakeside route. On its last day of service in 1950, No. 5687 was scrapped on-site at Roland and Lake Avenues.

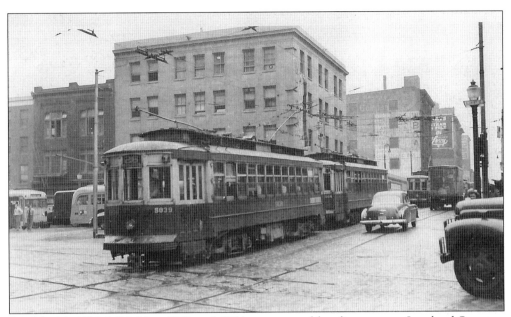

On July 26, 1950, MUs Nos. 5839 and 5854 are snapped heading east on Lombard Street at Howard Street en route to Sparrows Point. Three days later, the line was cut back and thereafter operated only between Highlandtown and Sparrows Point.

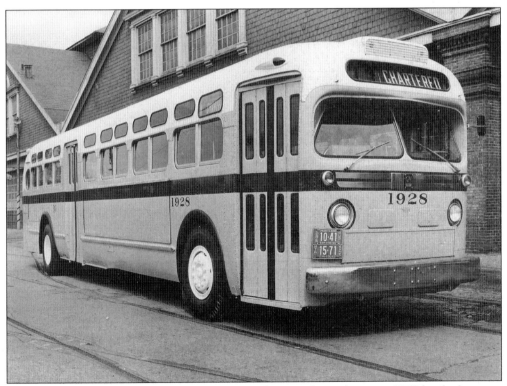

GM bus No. 1928 looks sharp in this early 1963 photograph. By this time, BTC bus bodies were a mint green color with a darker green accent stripe, topped off by a white roof.

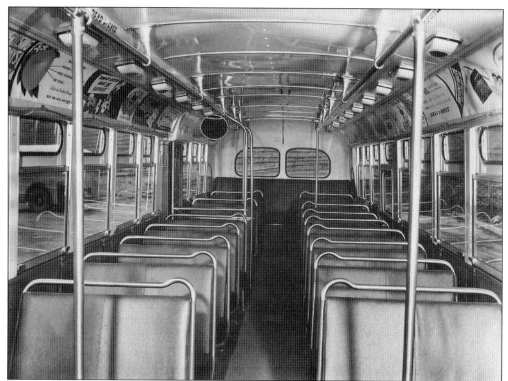

Here is an interior shot of a typical BTC General Motors coach of the 1940s, 1950s, and early 1960s.

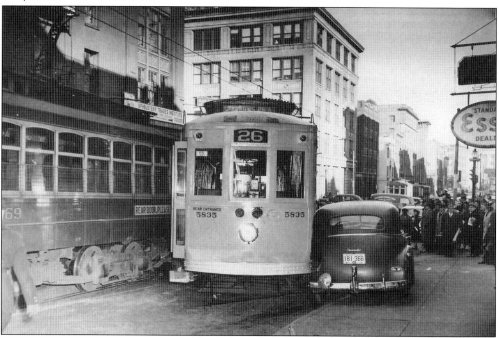

Two semis and a Chevrolet got tangled up in this mishap on Lombard Street near Light Street on December 30, 1949. By the look of things, the No. 5835, a 1919 Brill, got the worst of it.

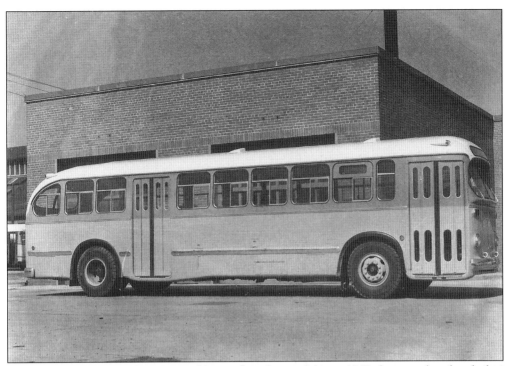

Another ACF Brill gasoline-powered bus is the subject of this *c.* 1947 photograph, taken before the fleet number and BTC markings were applied.

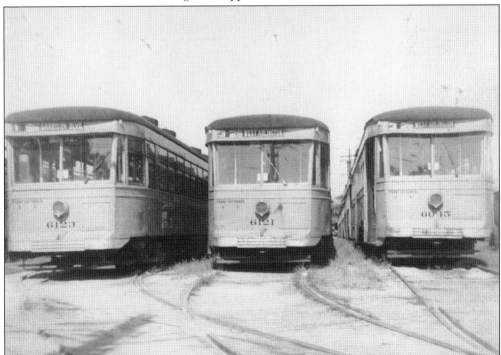

Photographer Charles Margolis shot this trio of Peter Witt cars, the Nos. 6123, 6121, and 6045, at the Belvedere car house on June 17, 1954.

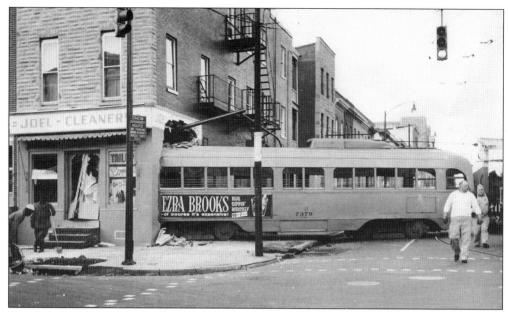

Here is one way to pick up the dry cleaning. On the morning of November 25, 1961, PCC No. 7379 derailed while turning onto Gilmor Street from westbound Pratt Street. The motorman and seven passengers were hurt. Six people in the building escaped without injury. It took five hours to extricate No. 7379 from the building.

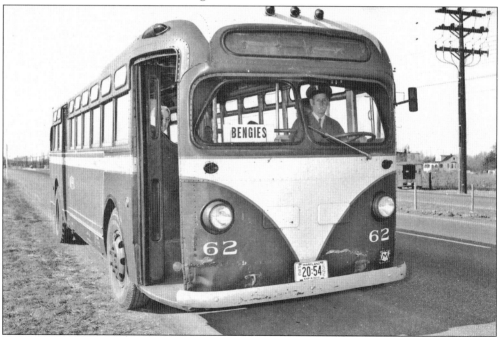

Rosedale Passenger Lines (RPL) was one of the area's last independent transit operators. Operating between East Baltimore and eastern Baltimore County, the RPL also maintained a fleet of school buses at their facility at Philadelphia and Chesaco Roads. GM bus No. 62, en route to Bengies in 1961, looks a little tattered, evidenced by the patched sheet metal across its bottom front. (Courtesy Baltimore County Public Library.)

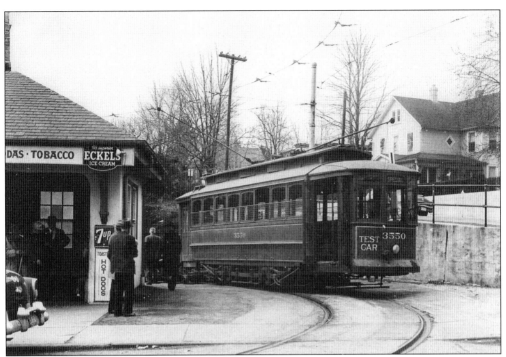

Test Car No. 3550 looks ready to leave the Overlea loop in this shot from the 1950s. The car tested rail bonds system-wide once each year. Restored to its original configuration as a passenger car, it is now No. 4533 at the Baltimore Streetcar Museum.

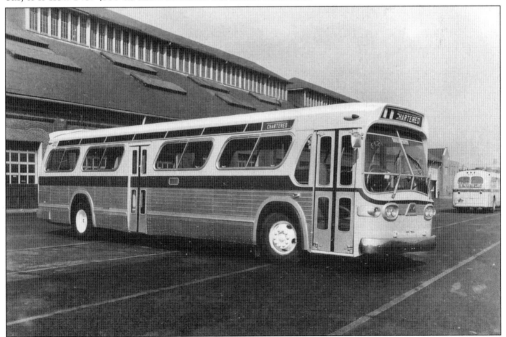

Unmarked and unnumbered, one of the first of the so-called "fishbowl" buses, a GM TDH-5303, arrived in 1963. They were the first air-conditioned transit vehicles in Baltimore. The "fishbowl" reference was attributed to the large windshield.

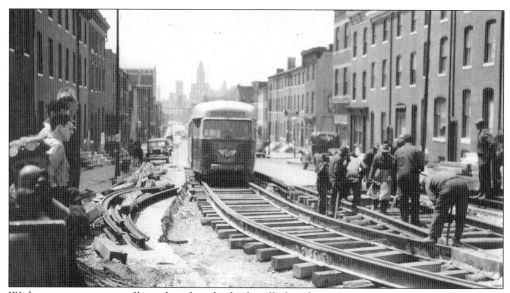

With it accent wings still in place beside the headlight, this PCC unit waits on track work on eastbound Pratt Street near Wolfe Street in 1948. When the PCCs required bodywork, technicians found it next to impossible to reattach the decorative wings, which would explain why some cars had them and others did not.

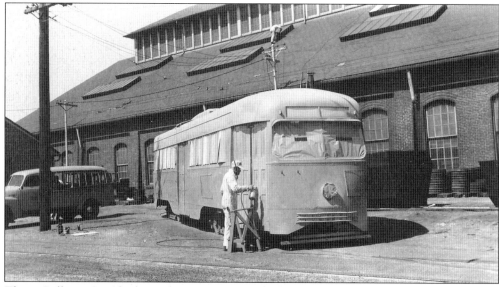

That is Pullman-Standard PCC No. 7084 under a fresh coat of paint in this shot taken at Carroll Park in 1956. The No. 7084 arrived in Baltimore in 1941.

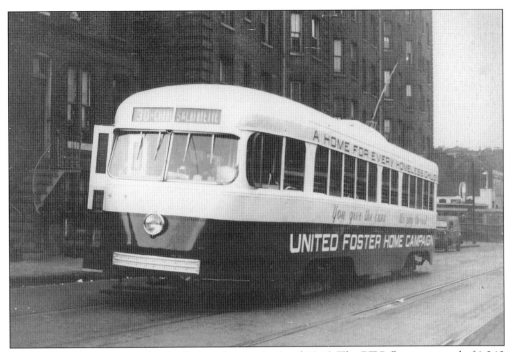

PCC No. 7387 was snapped on Lafayette Avenue in April 1946. The BTC fleet consisted of 1,040 streetcars at this time, 275 of which were PCCs.

A pair of Peter Witts, the No. 6020 and an unidentified unit, met by accident at Fayette and Holiday Streets on January 26, 1954. Dazed passengers were still aboard the car on the right when this photograph was taken.

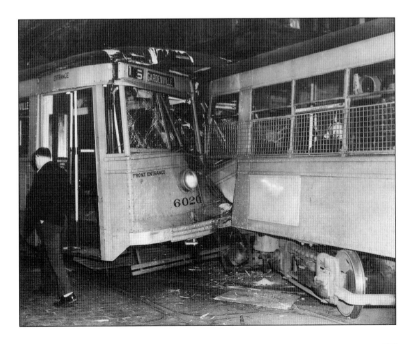

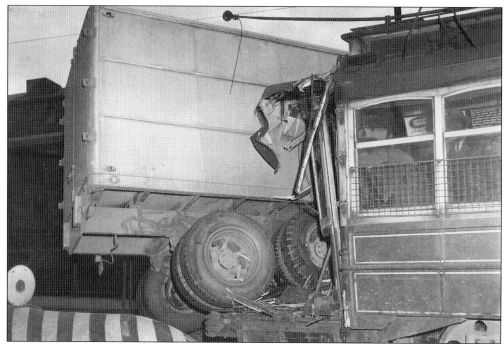

In another mishap, nine passengers and motorman Clarence Bedell were hurt when this truck seemingly went airborne and sheered off the closed platform of a BTC semi. The collision occurred at Lombard Street and the Fallsway on March 12, 1949. As car and track maintenance were cut back and automotive traffic increased, streetcar accidents became more frequent, much to the delight of bus supporters.

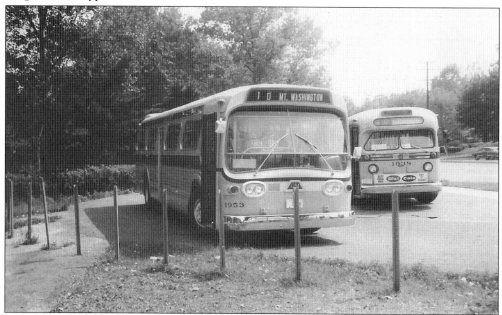

Old meets new in this August 16, 1963, photograph taken on the No. 10 route in Mount Washington. Bus No. 1938 operated from 1959 to 1980, while No. 1953 ran over Baltimore streets from 1963 to 1985.

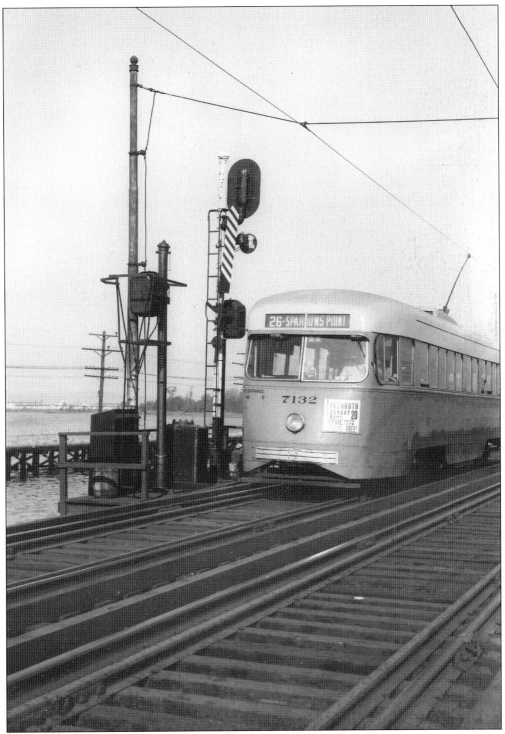

Pullman-Standard PCC No. 7132 is captured racing across the Bear Creek bridge toward Bethlehem Steel in the 1950s. Streetcar service to Sparrows Point ran from 1903 to 1958. (Courtesy the author's collection.)

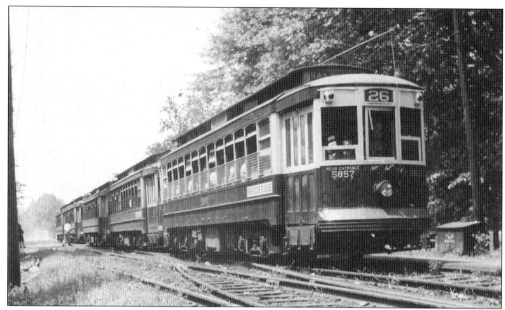

The fact that these cars at Bay Shore Park are still relatively full in the mid 1940s attests to the popularity of the resort. BTC's predecessor, the United Railways and Electric Company, also owned Riverview Park, which was on Colgate Creek. Riverview Park closed in 1927 to make way for a Western Electric Company plant at the Broening Highway site.

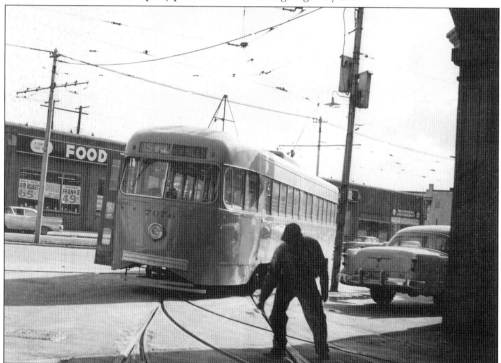

Into the barn comes PCC No. 7076 in this 1959 photograph. The employee at the lower right is switching tracks to accommodate the car in the Belvedere car house. (Courtesy Maryland Department, Enoch Pratt Free Library.)

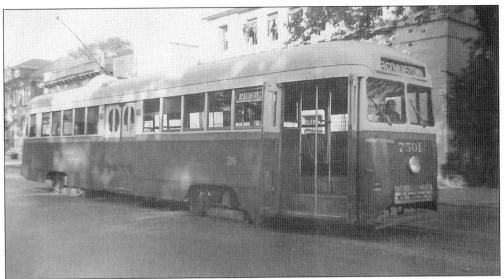

Baltimore's only Brilliner, No. 7501, operated exclusively on the No. 8 Towson line. Brill was the only car maker not to join the consortium that designed the PCC car in the 1930s. Semicircular windows accented the doors, giving them a tavern-like appearance. By the time this photograph was taken, the unique windows had been replaced on the front door.

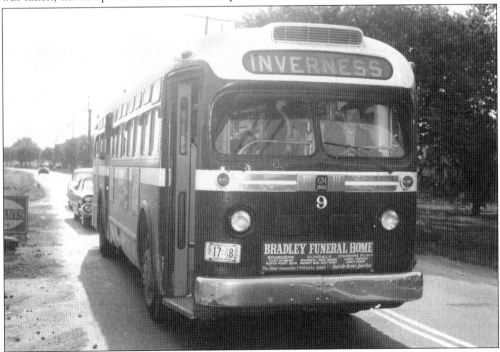

Despite being a fourth-grade dropout, Ted Graff was a hardworking Dundalk entrepreneur who, with his wife, Juanita, owned retail stores, a cab company, a limo service, and more. Perhaps his best-known enterprise was the Dundalk Bus Lines, which operated from the 1940s until 1972. Locals affectionately referred to the aging fleet as "the Blue Bus." In this shot from October 10, 1960, bus No. 9 appears to be heading down Trappe Road toward the Inverness community. (Courtesy Baltimore County Public Library.)

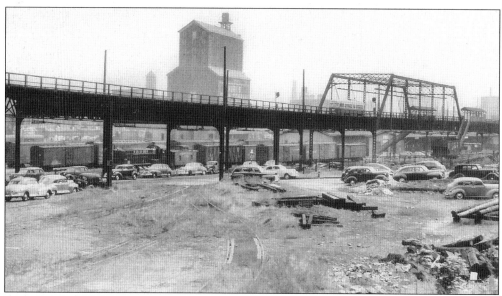

Existing Northern Central railroad tracks on Guilford Avenue made it necessary for construction of the Guilford Avenue El by the Lake Roland Elevated Railway in 1893. Just under a mile in length, it was the first elevated electric railway in America. Operation over the elevated tracks ended on January 1, 1950, and the El was demolished shortly afterward. PCC No. 7030 was passing over when this photograph was snapped on September 22, 1949.

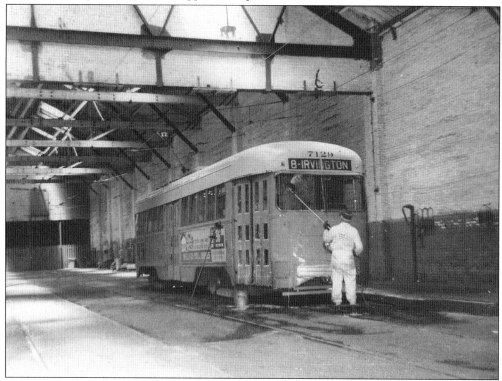

Pullman-Standard PCC No. 7129 gets perhaps its last bath at the Irvington car house in this 1963 photograph. (Courtesy Maryland Department, Enoch Pratt Free Library.)

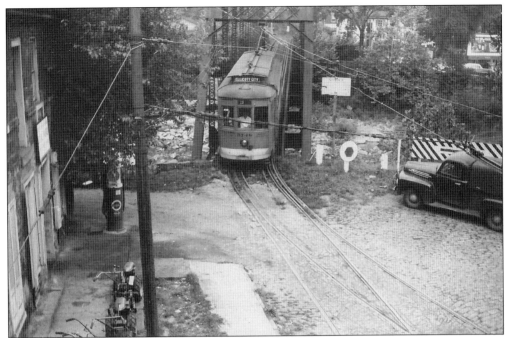

In September 1954, Brill semi No. 5748 crossed over the Patapsco River into Ellicott City. Built in 1918, the No. 5748 is now at the Seashore Trolley Museum in Kennebunkport, Maine.

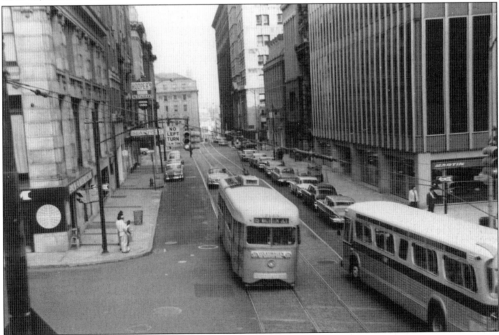

For just a second on October 20, 1963, Baltimore's mass transit past and future came together—then appropriately headed off in opposite directions. PCC No. 7143, a 1944 Pullman-Standard, and a fishbowl GM bus pass each other on Fayette Street at Charles Street. Fourteen days later, on November 3, 1963, Baltimore's streetcar service ended. (Courtesy Maryland Department, Enoch Pratt Free Library.)

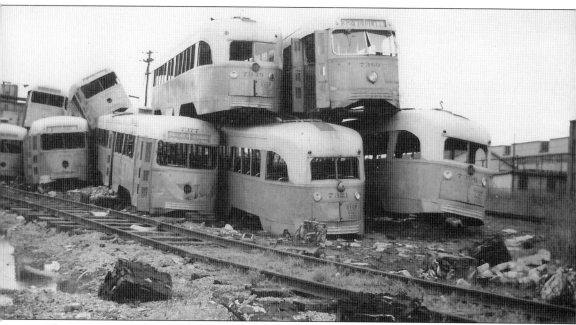

This grim scene, taken at the Boston Metals scrap yard in Curtis Bay in 1964, is reminiscent of a photograph of war casualties. Stripped of all salvageable parts, PCCs Nos. 7353, 7415, 7315, 7309, 7377, 7349, 7321, 7369, and 7306 sit silently, waiting for the cutting torch.

Six

THE BALTIMORE STREETCAR MUSEUM

The Baltimore Streetcar Museum (BSM) is the end result of some truly dedicated and tireless volunteers, not to mention the foresight of a few United Railways and Electric and Baltimore Transit Company executives. Early on, many of the vehicles that presently call the BSM home were stored haphazardly in United and BTC facilities, often moved from one to another as the need for space grew or diminished. Calls for a local transportation museum were being made long before ground was broken for the museum on November 4, 1967. Opened in July 1970, the Baltimore Streetcar Museum is the only downtown streetcar museum in America. Located at 1901 Falls Road, two blocks from Amtrak's Pennsylvania Station, the BSM is a monument to the efforts of the late George Nixon.

More than a dozen vehicles from Baltimore's transportation past can be seen at any given time at the Baltimore Streetcar Museum, and most can be ridden. They range from an unrestored 1859 horsecar, to the youngest car in the BSM fleet, the 1944 PCC No. 7407, which has the distinction of being the last streetcar to operate on Baltimore streets on the morning of November 3, 1963.

The Baltimore Streetcar Museum also features a visitor's center with a gift shop, indoor exhibits, train/streetcar layouts, and an auditorium for presentations, and it is the home of the Baltimore Chapter of the National Railway Historical Society. The Maryland Rail Heritage Library, featuring an extensive collection of books, photographs, timetables, and the like, is located on the second floor of the visitor's center.

The BSM is open Sundays year round, plus Saturdays during the summer. A nonprofit 501 (c) (3) museum, it relies on members and donations. The Web site for the Baltimore Streetcar Museum is www.baltimorestreetcar.org.

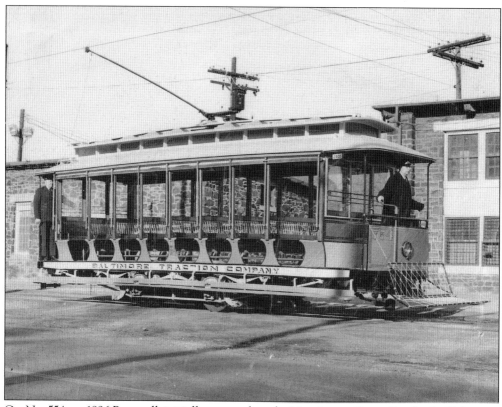

Car No. 554, an 1896 Brownell, initially operated on the Huntington Street line for the Baltimore Traction Company. It is shown here passing the old Maryland and Pennsylvania Railroad roundhouse on Falls Road with George Nixon at the controls.

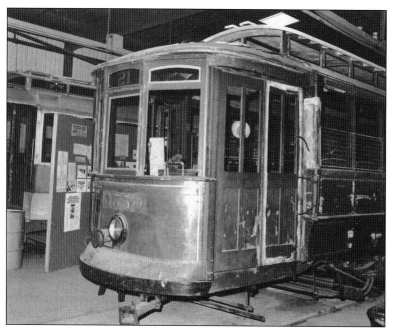

The No. 4533 is a 1904 Brill that originally ran over North Avenue as car No. 1306. In 1940, it was converted to test car No. 3550 and served in that capacity until 1963. Restored to its original condition as a passenger car, it was assigned number 4533 by the BSM.

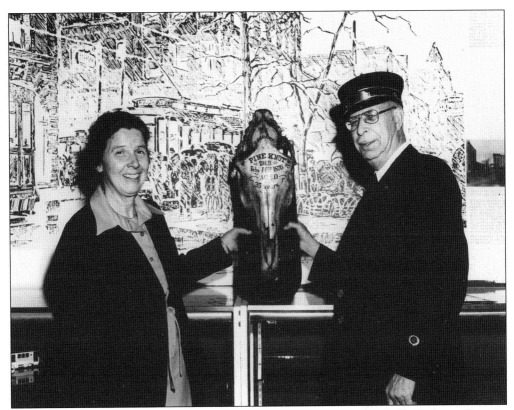

Perhaps the most curious exhibit in any transportation museum is this skull of a horse. Born in 1841, Pine Knott pulled horsecars for the Baltimore City Passenger Railway. Jean Worthley (left) of the National History Society of Maryland presents Pine Knott's skull to BSM curator George Nixon on March 5, 1980.

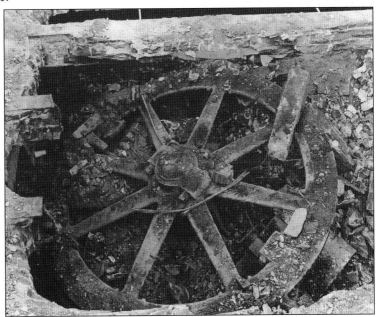

In November 1974, utility workers unearthed two large vaults beneath Paca Street north of Fayette Street. Inside each was a cast-iron wheel 11 feet in diameter from Baltimore's short-lived cable car service dating back to 1891.

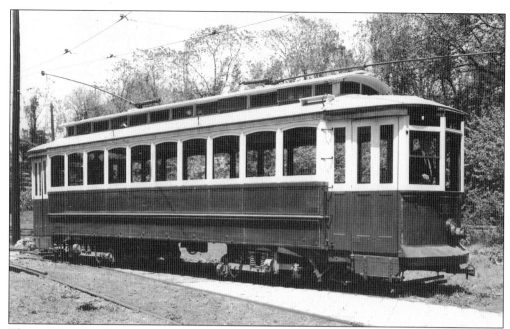

That is BSM founder George Nixon at the controls of No. 3828, a 1902 Brill 28-foot closed car that operated until 1930.

This interior shot of No. 3828 is a testament to the skills of the volunteers who restored her at the BSM.

One of the cable car wheels found beneath Paca Street is seen in this 1974 photograph being loaded onto a truck to be transported to the Baltimore Streetcar Museum, where it is on display.

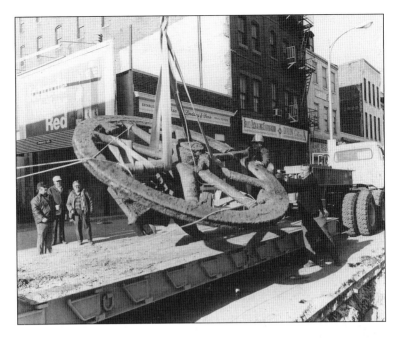

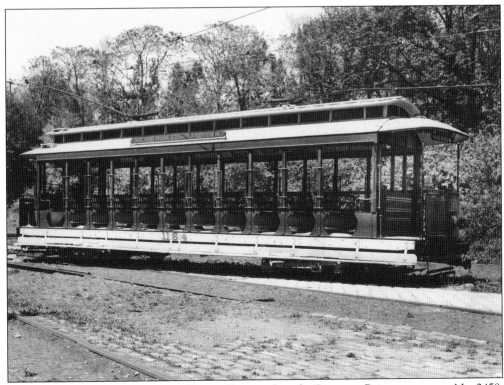

Built in 1902, Brill open car No. 1164 initially served on the Sparrows Point route as car No. 2458. It was taken out of service with the rest of the open cars in the fleet in 1923.

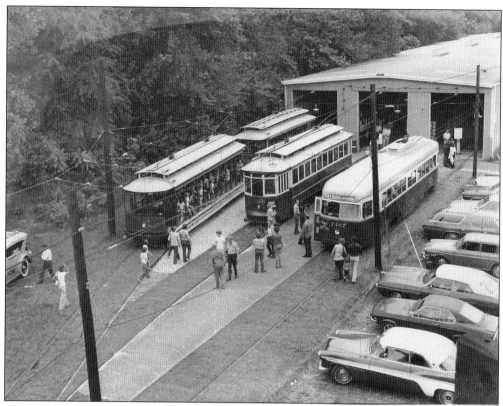

The BSM opened in 1970. Shortly thereafter, this bird's-eye view of cars Nos. 1164, 3828, and 7407 and the car house was taken from a railroad bridge over Falls Road.

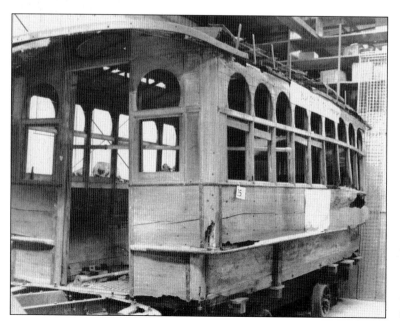

Little is known about horsecar !except that it is beyond restoration. Believed to be from 1859, it remains in the BSM car house as of October 2007.

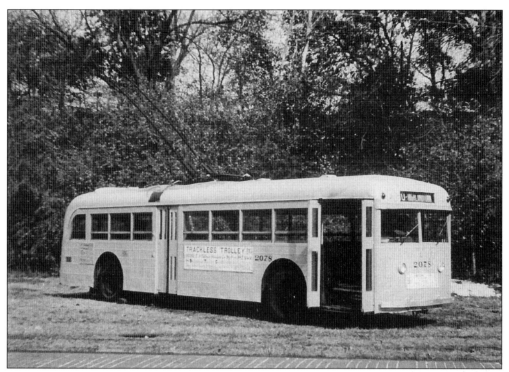

Trackless trolley No. 2078, manufactured by Pullman-Standard, is also part of the BSM collection.

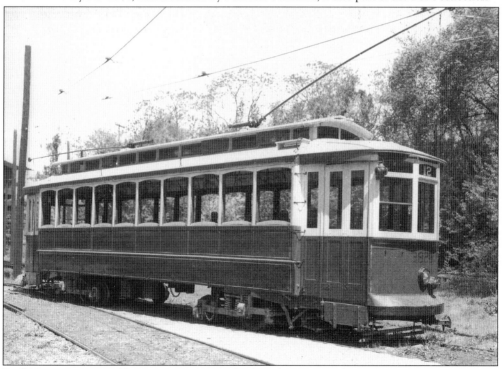

Brill No. 3828 originally wore No. 1028 and, when first acquired in 1902, was assigned to the Roland Park–Highlandtown route.

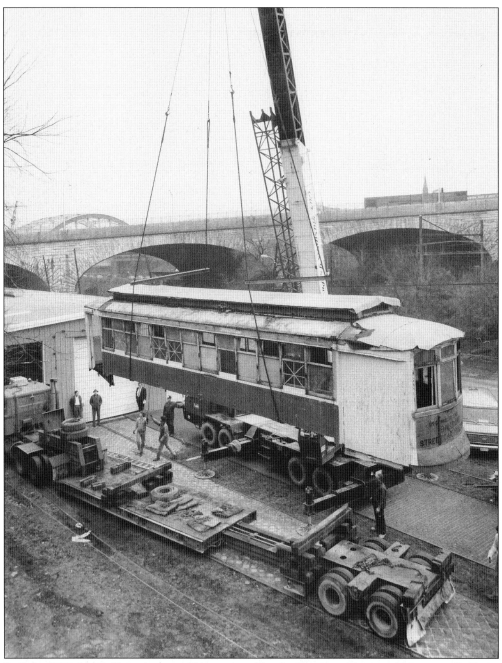

Built in 1917, this Brill semi-convertible was used by the Newport News and Hampton Railway, Gas, and Electric Company. Found in 1977, it had been converted into a private home near Yorktown, Virginia. Transported to the BSM in November of that year, it was placed in the car house but remains unrestored.

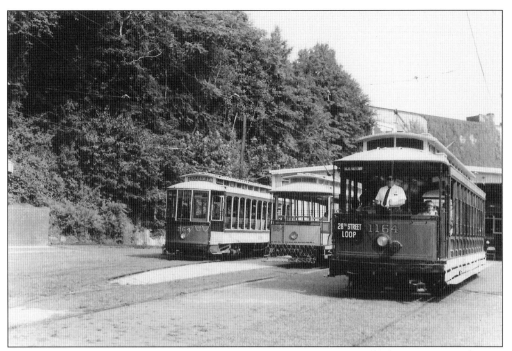

Cars Nos. 264, 554, and 1164 were all set to carry streetcar fans from the BSM car house to the Twenty-eighth Street loop when this photograph was taken in the 1980s.

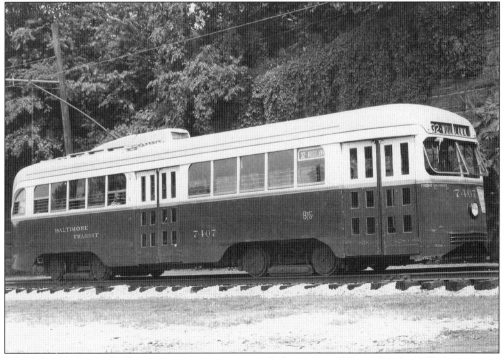

PCC No. 7407 was the last streetcar to operate in Baltimore on November 3, 1963. It sports its original color scheme: an Alexandria blue (which is actually dark green) body, silver-gray roof, cream top, and orange belt stripe.

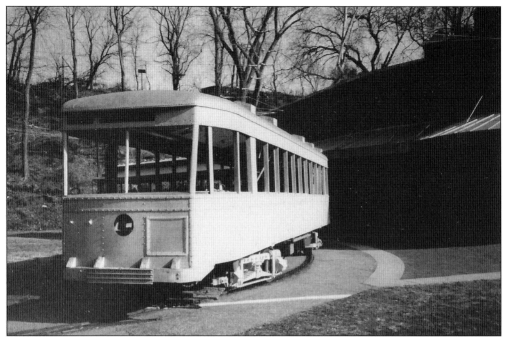

Peter Witt No. 6119 was built in 1930 by Brill and ran until 1955. It was being restored when this photograph was taken.

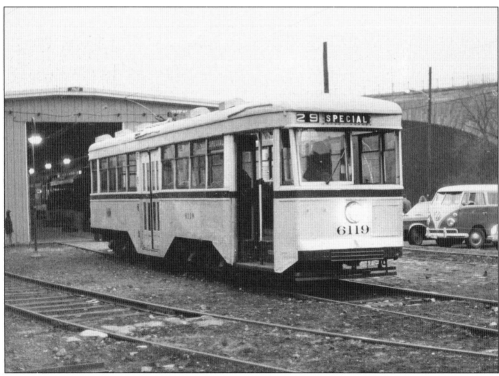

Restoration complete, the No. 6119 is photographed in front of the BSM car house during the 1980s.

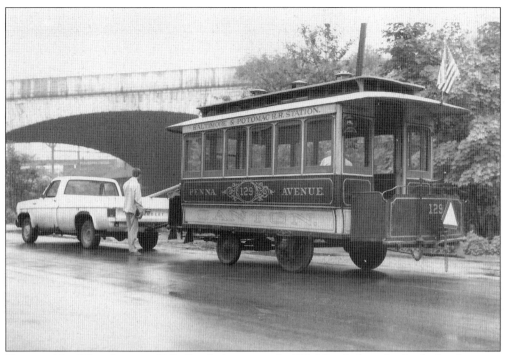

Horsecar No. 129 is shown on Falls Road adjacent to the BSM. It is believed to be the last horsecar used in Baltimore, retiring in 1898.

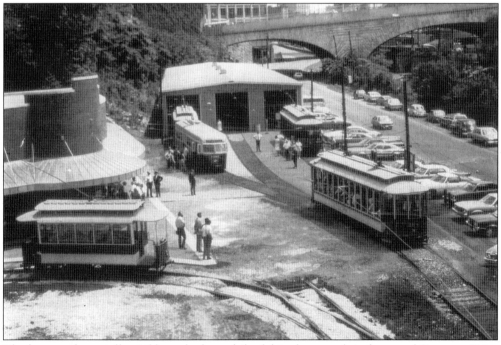

The loop track partially visible at the lower left of this photograph is the actual Sparrows Point loop. BSM volunteers are salvage experts out of necessity.

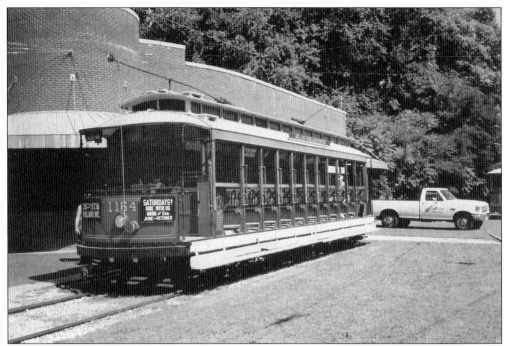

Car No. 1164 appear ready for the trip up Falls Road and the Twenty-eighth Street loop. BSM volunteer motormen receive multiple weeks of training before being certified to operate the vintage cars.

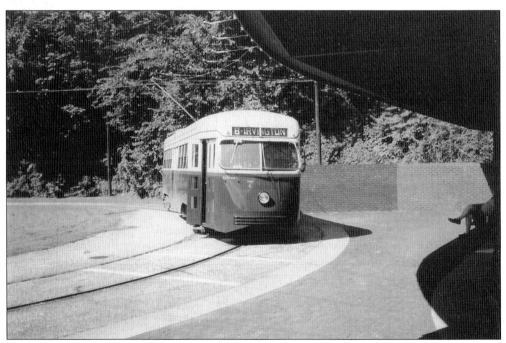

On the BSM Gift Shop/Sparrows Point loop is PCC No. 7407. Weighing 37,900 pounds, it seats 55 passengers.

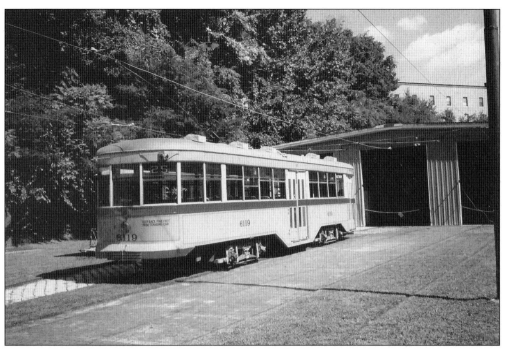

Here is another look at Peter Witt car No. 6119. Like the PCCs, it is 46 feet long.

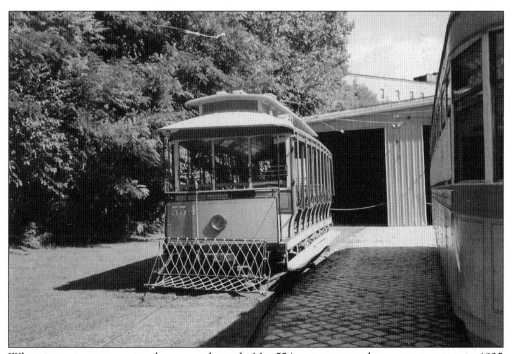

When its passenger service days were through, No. 554 was converted to a snow scraper in 1925 and renumbered 3390. Restored to its 1896 glory, it carries passengers again at the Baltimore Streetcar Museum.

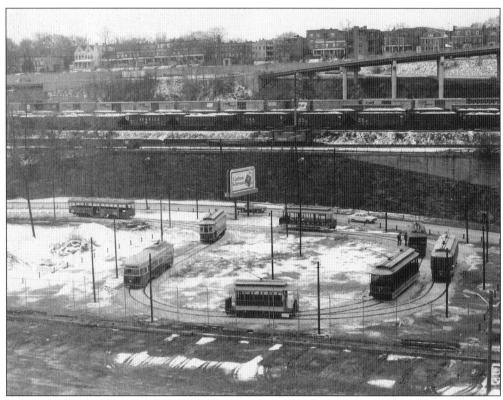

When the BSM's Twenty-eighth Street loop was completed, the rolling stock celebrated with a group photograph.

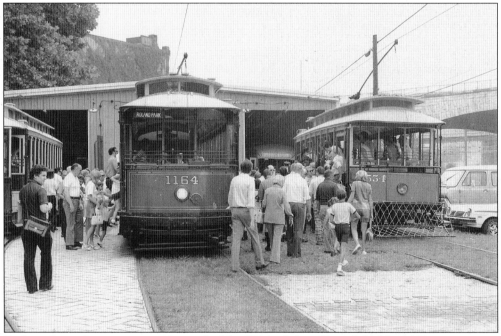

Back at the car house, passengers exit the No. 554 (right) and board the No. 1164.

Here is an interior view of No. 6119. When it began service in 1930, the No. 6119 operated on the No. 32 Woodlawn route. (Photograph by the author.)

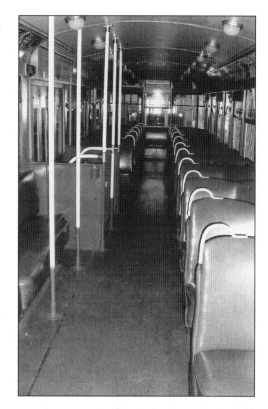

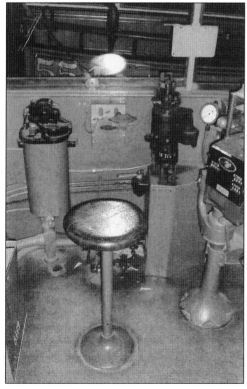

Of course, the motorman's comfort was always of paramount importance, as evidenced by this sad-looking stool inside Peter Witt No. 6119. (Photograph by the author.)

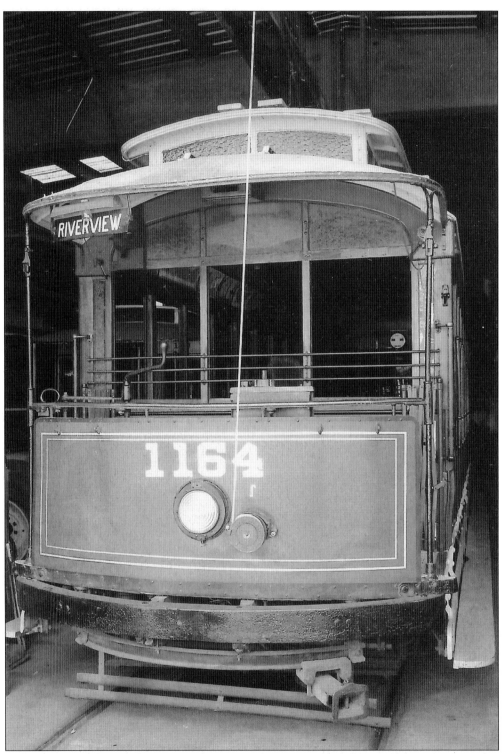

The No. 1164 is a truly handsome car with a cream-colored roof and red body. In 2007, it was 105 years old and still going strong. (Photograph by the author.)

Just to have so many vintage 19th- and 20th-century cars on display alone would make most streetcar enthusiasts happy, but at the BSM, nearly all the rolling stock still rolls! (Photograph by the author.)

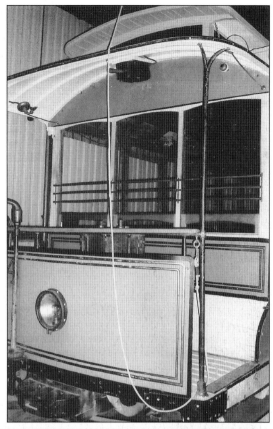

The No. 554's original brass control plate is used today exactly as it was in 1896. (Photograph by the author.)

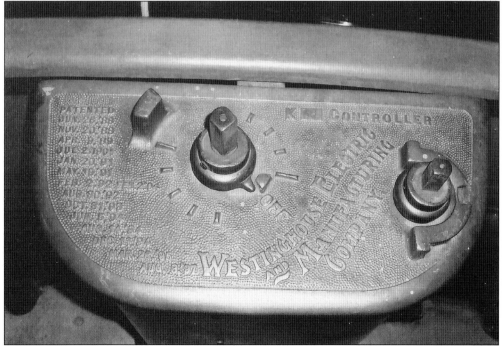

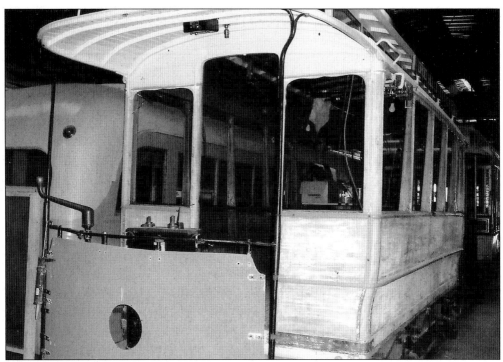

Not an organization to rest on its laurels, in the fall of 2007, BSM volunteers were hard at work restoring yet another vintage Baltimore streetcar, No. 417. (Photograph by the author.)

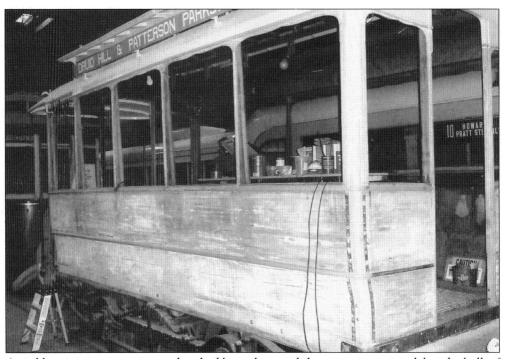

At publication time, exterior sanding had been done and the route sign painted, but the bulk of restoration work on the No. 417 remained. (Photograph by the author.)

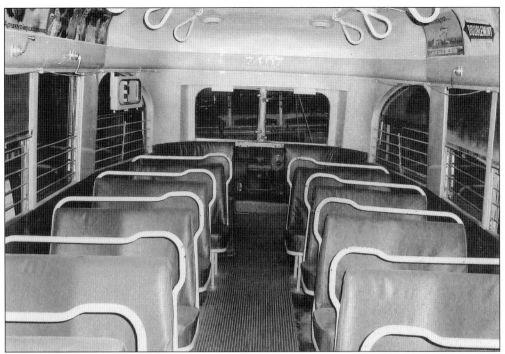

This interior photograph could very well be from 1944 when car No. 7407 rolled off the Pullman-Standard production line. In reality, it was taken 63 years later inside the BSM car shop. Authenticity both inside and out is the BSM's objective. (Photograph by the author.)

Another interior shot captures the meticulous workmanship needed to restore the 1896 flip-back benches on car No. 554. (Photograph by the author.)

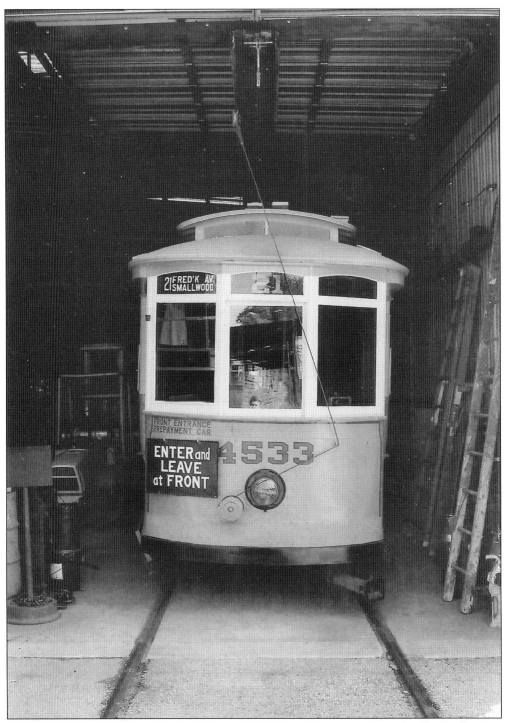

Here is another look at the No. 4533. When it arrived in Baltimore in 1904, it initially wore No. 1306. It was renumbered five times—447, 2307, 3407, 4533, and 3550—as its assignments changed. Suffice it to say that United/BTC got their money's worth out of this car. (Photograph by the author.)

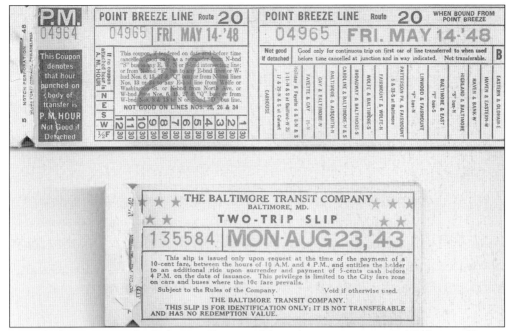

Some lucky visitors to the Baltimore Streetcar Museum receive an original Baltimore Transit Company transfer or two-ride slip from the 1930s and 1940s. The museum reaches out to young people with private parties and school field trips in an effort to create a new generation of rail transit fans. (Photograph by the author.)

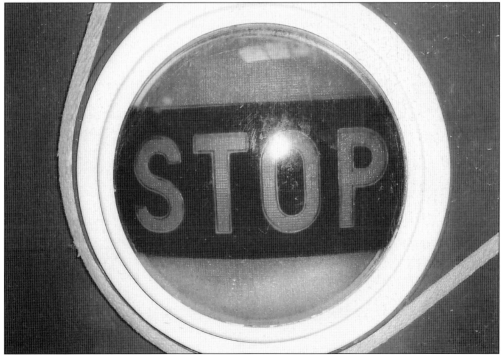

This extreme close up shows one of the brake lights on PCC No. 7407—an appropriate place for us to stop. (Photograph by the author.)

ACROSS AMERICA, PEOPLE ARE DISCOVERING
SOMETHING WONDERFUL. THEIR HERITAGE.

Arcadia Publishing is the leading local history publisher in the United States. With more than 4,000 titles in print and hundreds of new titles released every year, Arcadia has extensive specialized experience chronicling the history of communities and celebrating America's hidden stories, bringing to life the people, places, and events from the past. To discover the history of other communities across the nation, please visit:

www.arcadiapublishing.com

Customized search tools allow you to find regional history books about the town where you grew up, the cities where your friends and family live, the town where your parents met, or even that retirement spot you've been dreaming about.